C000110503

IMAGES OF ENGLAND

LAW AND ORDER IN
MANCHESTER

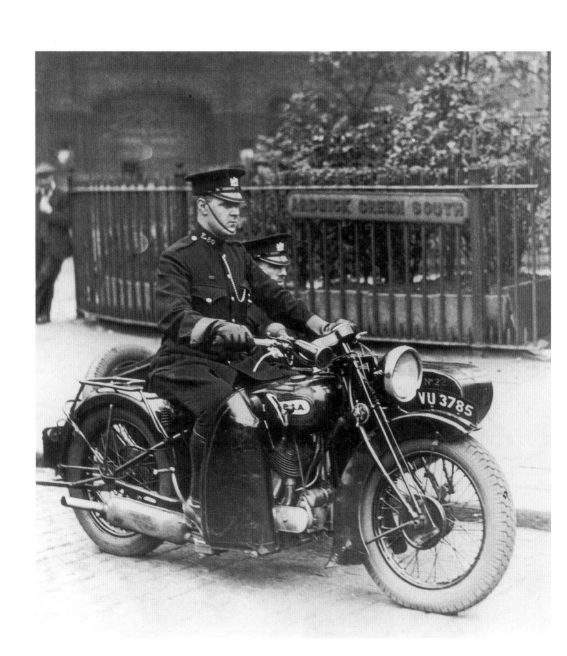

IMAGES OF ENGLAND

LAW AND ORDER IN
MANCHESTER

DUNCAN BROADY AND DAVE TETLOW

TEMPUS

We wish to dedicate this book to Janet Broady and Gill Tetlow to thank them for all their help and support in our work.

Frontispiece: Manchester City Police BSA motorcycle and sidecar, *c.* 1930, outside the Ardwick Green South police box.

First published 2005

Tempus Publishing Limited
The Mill, Brimscombe Port,
Stroud, Gloucestershire, GL5 2QG
www.tempus-publishing.com

© Duncan Broady and Dave Tetlow, 2005

The right of Duncan Broady and Dave Tetlow to be identified as the Author of this work has been asserted in accordance with the Copyrights, Designs and Patents Act 1988.

British Library Cataloguing in Publication Data.
A catalogue record for this book is available from the British Library.

ISBN 0 7524 3713 5

Typesetting and origination by Tempus Publishing Limited.
Printed in Great Britain.

Contents

Acknowledgements

The photographs contained within this book form part of the collection held at Greater Manchester Police Museum, which is based in the Victorian police station (opened in 1879) on Newton Street, off Piccadilly in Manchester's city centre. Visitors can inspect the station's original cells and charge office, together with a Victorian magistrates' court. There are also displays of vehicles, uniforms, forensic science equipment and a selection of police insignia from around the world. The museum's archive collections cover the Greater Manchester area and range in date from the early nineteenth century to the present day. Personal records, photographs and memorabilia, together with official reports and service details, provide a fascinating record of the ever-changing role of the police force in the Manchester area.

Funded by Greater Manchester Police, the museum has grown steadily since its inception in 1981, and is currently the largest museum of its type in the UK.

The museum is open every Tuesday between 10.30 a.m. and 3.00 p.m. and on other weekdays by appointment for group visits and researchers.

Tel: 0161 856 3287
Email: police.museum@gmp.police.uk

Duncan Broady has been the Curator of the museum since 1981. Dave Tetlow has been the Museum Officer since 2000.

Introduction

We are all fascinated by police dramas and documentaries on the television and detective stories in print, but have you ever wondered why a constable is so called or whether policemen have always worn their iconic helmets? When we see police officers on the streets today, do we ever stop and think about the history behind what they are wearing, the equipment they are carrying and how all of this has evolved over the years?

Law and order in Great Britain has traditionally had two main characteristics – it is local in nature and civil, rather than military, in origin. The earliest law officer that we encounter in Manchester is the constable, who was responsible for preserving the king's peace and maintaining law and order in the township. The constables of Manchester were chosen by the Court Leet of Manchester, a self appointed body of prosperous citizens. Two were nominated and they served for one year only and were unpaid. A deputy constable and a beadle, both of whom were paid small salaries, assisted them in their duties. The constables were required to deliver wanted persons to the magistrates, punish guilty criminals, ensure vagrants were moved on and collect taxes and levies.

In those early days justice was, if not instant, delivered fairly rapidly and in public. A fine, a whipping or a turn in the stocks would be the usual punishments. For women who had been found guilty of being malicious gossips, the ducking stool was sometimes used. One such device was to be found by a large pool in what is now Piccadilly Gardens.

Not surprisingly, the constable's job was not a popular one. Anyone refusing the dubious public honour of becoming a constable could be fined heavily and many preferred this to taking the job. The reluctant would-be constable could also hire and pay for a substitute to do his work for him.

At night a separate body of wealthy citizens, known as the Police Commissioners, organised patrols of nightwatchmen. Carrying a lantern, a truncheon and a large wooden alarm rattle called a rick rack, they walked the streets and would detain anyone found out after a certain time of night, on the grounds that they were suspicious. They also called out the hour and the state of the weather. To hold suspects overnight, or during

the day, small stone buildings called lock-ups were provided. Finally, if it was market day or a major event was planned in the town, ordinary people could be sworn in as special constables, but only for that particular occasion. None of these groups worked well with each other and neither was there any way of generating enough money to pay for an efficient police service in the town.

In 1829 Sir Robert Peel, then Home Secretary, established the England's first professional police force in London. Retaining the name constables, but nicknamed 'Peelers' or 'Bobbies' after their founder, these officers were permanent, full-time and paid. They wore a uniform similar to contemporary civilian fashion of top hat and tailcoat, in order to distinguish them from the army. Concealed in a pocket in the tail of their coat was a stout wooden truncheon for protection. This force was to become a model for the rest of the country. The creation of elected town councils, a process known as incorporation, provided the funding mechanism that allowed towns like Manchester to found their own police forces based on the London model. Rate money, collected by the new corporation, could be used to partly pay for a police force, with central government contributing the remainder – a process that continues to this day.

Manchester's first professional police force took to the streets in 1839, but the process did not run smoothly. Powerful groups opposed to incorporation claimed the charter obtained for Manchester was legally flawed and therefore invalid. Confusion reigned and within a few months the Government despatched Sir Charles Shaw to Manchester, to take over the force and run it until such time as the local inhabitants had resolved the Charter of Incorporation. Only by 1842 was the Government able to hand control back to the Manchester Council. In 1844, Manchester's established strength comprised the chief constable, Captain Edward Willis, a treasurer, a surgeon, a chief clerk, and a store keeper. There was a single chief superintendent, four superintendents, one in charge of each division, eleven inspectors, five acting inspectors, thirty-seven sub-inspectors and 329 constables. Notice the rank of Sergeant was not yet recognised. The divisions of the force were titled Town Hall, Oldham, Ardwick and Hulme and labelled A to D respectively.

From these shaky beginnings, Manchester's police officers secured the support and, in most cases, the respect of the town's inhabitants during the course of the nineteenth century. The force expanded to take in Manchester's ever-increasing boundaries and by 1908, the Manchester City Police comprised a force of 1,182 officers divided into four territorial divisions, A to D and the E Division consisting of Detectives Department, Courts and Chief Constable's Office. Constables marched out of twenty-four police stations and arrested over 19,000 people that year for offences ranging from murder (four), to malicious damage to fruit (one) and offences against the Musical Copyright Act (two). The highest number of arrests (8,000) related to drunkenness. The police also ran the ambulance service for Manchester, issued licenses to marine store dealers, pedlars and pawnbrokers, inspected common lodging houses, liberated 164 people who had locked themselves in their place of work, took in 2,800 lost dogs and returned nearly 4,000 lost children to their parents.

The story of the police service in Manchester is in broad terms the story of Manchester itself; every public event and every demonstration or march has required the presence of the police. Every change in the law, major disaster or triumphant parade has demanded a response from the police and so this photographic portrait of the police in Manchester will, it is hoped, reflect the wider social changes in this great and evolving city.

one

Early
Policing

Left: The 'hue and cry' – a witness to a crime raises the alarm and the chase begins, and so does policing!

Below: The Peterloo Massacre. A peaceful meeting about political reform held in Manchester's Peter's Field on 16 August 1819 ended in the killing of men, women and children by untrained yeomanry, whose heavy-handed tactics led to panic among the crowd. It was incidents like this that led to the call for an organised police force.

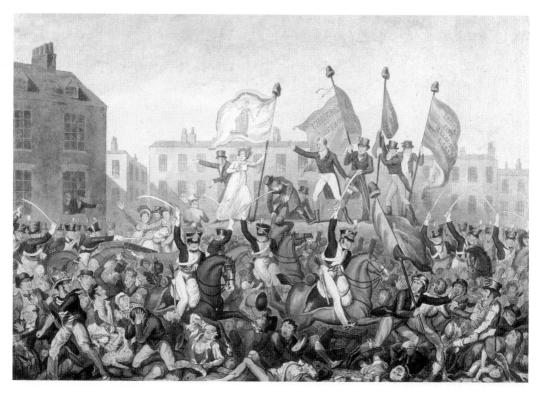

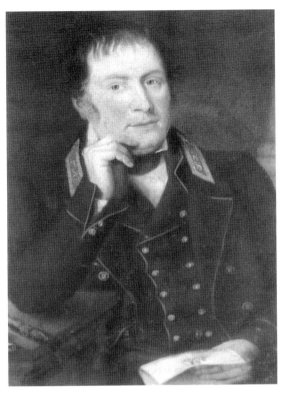

A Manchester Lock-Up Keeper in an early nineteenth-century portrait. His collar badges bear the initials LK and these officials supervised the small buildings designed to detain prisoners prior to their appearance before a magistrate. When the Manchester Borough Police was founded, a number of the Keepers became the town's first Detective Officers.

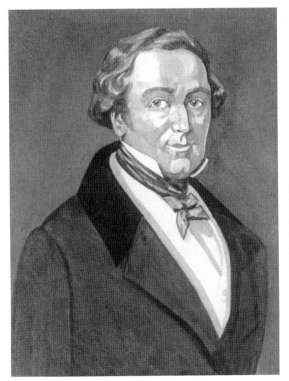

Sir Robert Peel (1788-1850), born near Bury and founder of the modern police force. As a reforming Home Secretary, he abolished the death penalty on over 100 offences and employed the first female prison warders. However, he is most remembered for the 1829 Metropolitan Police Act, which established a single, full-time and professional police force for London. It was Peel who insisted that his 'New Police' should be civil, rather than military, in nature and who decided that the first police officers should look like ordinary men and not soldiers. Manchester gained a London-style police force in 1839.

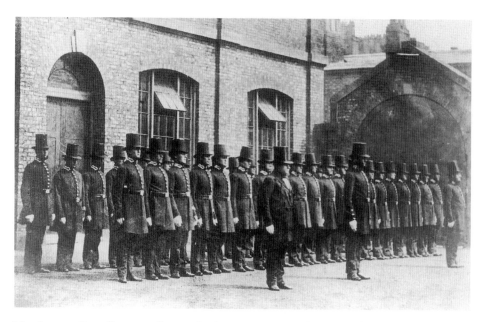

Manchester police officers parading-on for duty in the uniform worn between 1845 and 1865. The uniform resembled civilian dress of the day, rather than military uniform, as the public did not trust the army during this period. Sir Robert Peel wanted his officers to be reassuring and approachable.

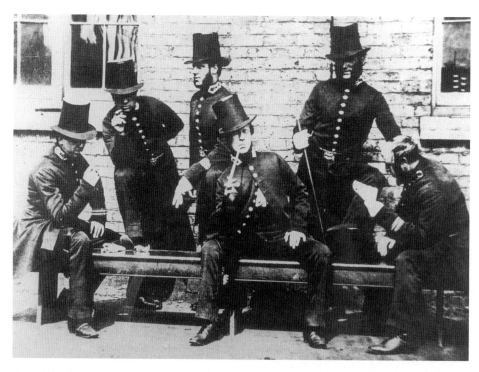

One of the first ever photographs of Manchester 'Peelers', c. 1840. In the earliest days of the police force, very little thought was given to the training of new constables. The authorities merely required that the man was physically fit and at least a minimum height, usually 5ft 9in.

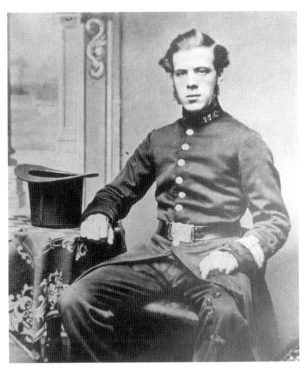

An early portrait of an unknown Manchester Peeler, *c.* 1859. He is unlikely to have seen his job as a career – most officers resigned after one or two year's service.

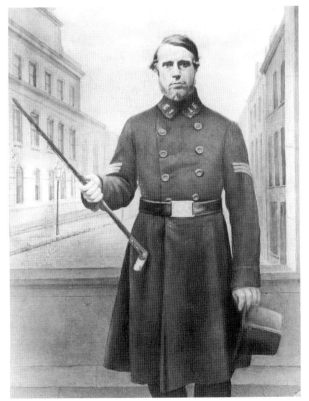

Sergeant Charles Brett, the first Manchester police officer to be killed on duty, 18 September 1867. He was shot dead by supporters of the Irish Nationalist group known as the 'Fenian Brotherhood' as they rescued two of their leaders from the prison van in which Brett was travelling. The van was approaching Belle Vue Prison on Hyde Road when it was attacked. Three men were held responsible for his death and later executed at the New Bailey Prison in Salford. They became known as the 'Manchester Martyrs'.

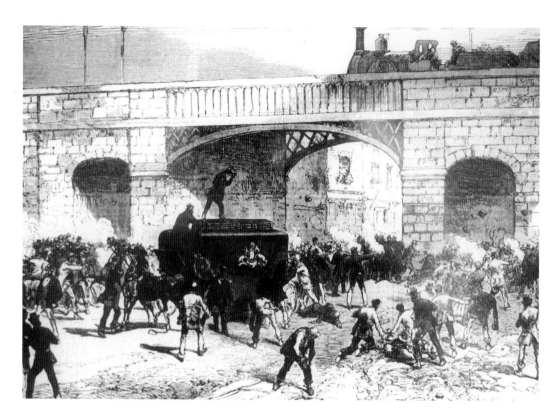

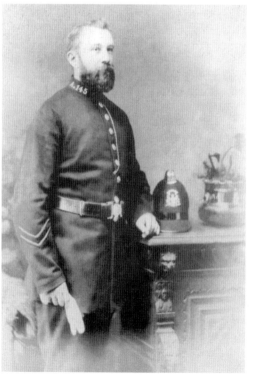

Above: The attack on the prison van that led to the death of Sergeant Brett, 1867. The attackers had hidden in the side arches of the bridge and ambushed the van as it passed by.

Left: Mark Langdon came all the way from Spreyton in Devon and joined the Manchester Police in July 1875. His son Arthur Milman Langdon also served in the force. It is rare to find clean-shaven officers in this period. As well as being fashionable, beards also avoided the need for shaving, which some chief constables regarded as a dangerous practice, leading to cuts, infection and illness.

Right: Police officers and detectives lurk mysteriously in front of the archway leading to the entrance of the Knott Mill police station near to what is now the G-Mex Centre. The station was one of the earliest in Manchester and was replaced by the Bridgewater Street police station in the 1890s.

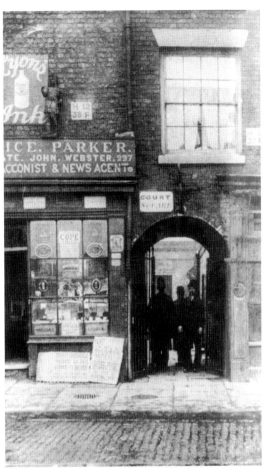

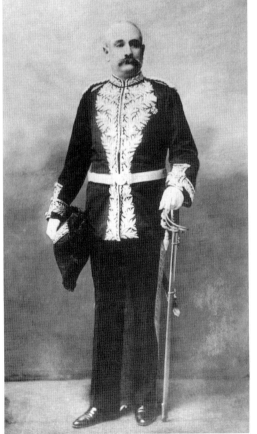

Left: Chief Constable Charles Malcolm Wood. Surprisingly, Wood was almost a total stranger to Manchester when he took office in 1879, having previously worked for the Sind Police in Karachi. An ambitious man of thirty-four, he was confident enough to apply for the post of Commissioner of the Metropolitan Police in the 1880s. He was unsuccessful and his later years were dogged by a scandal involving the corrupt Superintendent William Bannister of Manchester's D Division. A public enquiry was convened to resolve widespread anxiety about the efficiency of the force. Bannister was sacked and Wood was exonerated of blame, but the pressures of the enquiry caused him to retire in 1896, his health shattered.

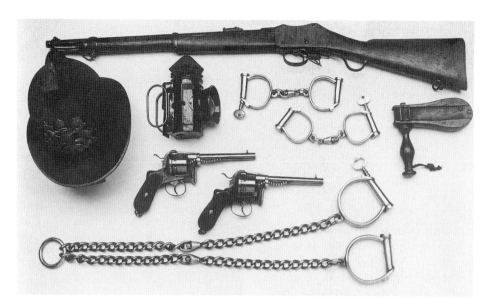

Victorian police equipment. From left to right: the original form of Manchester police helmet, which replaced the top hat in the early 1870s, a bullseye oil lantern, screw key handcuffs and finally on the right is a wooden alarm rattle, or rick rack, carried before the introduction of the familiar police whistle. Also present are leg irons, used up to 1900 by the drivers of prison vans. The Martini Henry rifle and pinfire revolvers would be carried if officers needed to arrest an armed criminal.

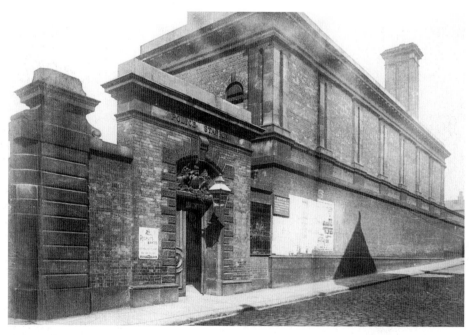

The massive frontage of Willert Street police station in Collyhurst. It was one of several police stations built in the city during the 1870s. All of these buildings were designed to act as miniature fortresses against mobs of citizens trying to rescue prisoners from the cells. Willert Street's walls were reinforced with sheets of iron and stout riot gates protected the entrance.

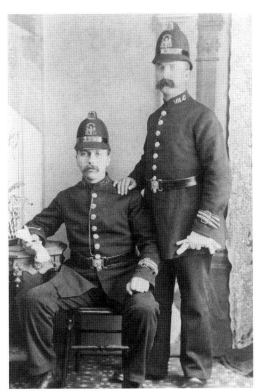

Left: PC Thomas Carlyle (standing) and a colleague pictured in the early 1890s, having just conveyed a violent prisoner on foot to the Prestwich Insane Asylum. They decided to treat themselves and have a photograph taken at a cost of one shilling, equivalent at the time to the cost of four pints of beer. Sadly, Thomas Carlyle had to leave the service in 1910. A drunken prisoner kicked him in the leg and his leg had to be amputated.

Below: At the centre of this busy scene in Market Street around 1905 can be seen a police officer giving directions to a pedestrian. The constable towers over him, as well he might, for the tallest officers were chosen for duty in the city centre, where they were much more likely to be seen by important visitors and dignitaries.

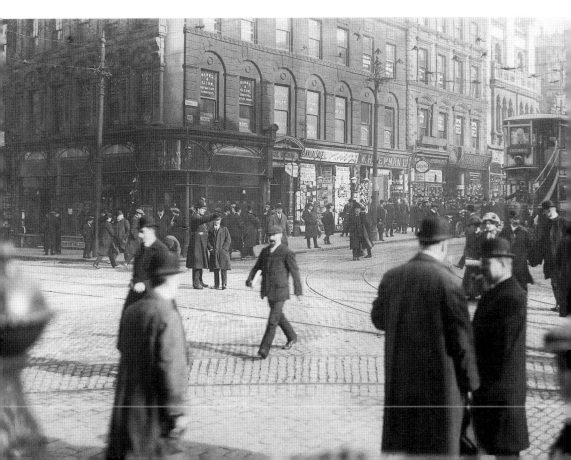

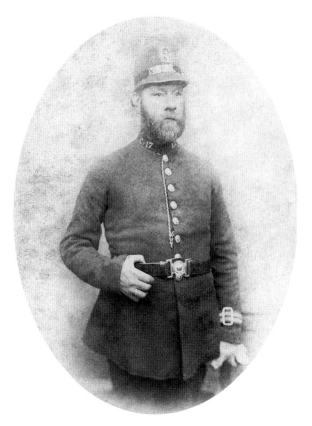

The perfectly named PC Isaac Ambler joined the force on 13 March 1860, aged twenty-two. Unlike most of his contemporaries who left after less than two years, Ambler, true to his name, sauntered slowly on, staying on the same division, never seeking promotion and keeping his nose clean. He finally arrived at his pension on 1 July 1891, having completed thirty-one years service.

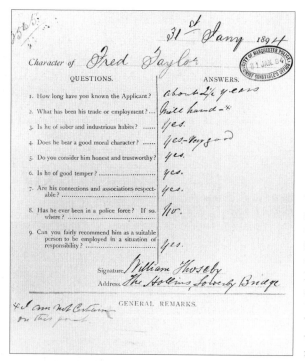

This is an example of the questionnaire sent out by the police in the nineteenth century to individuals providing a character reference for potential constables. William Thoseby of Sowerby Bridge confirms the sober, industrious and moral character of Fred Taylor in 1894. Fred was born in Mytholmroyd in Yorkshire and the faith of Mr Thoseby was not misplaced for Fred rose to the rank of chief superintendent.

two

Edwardian
Policing

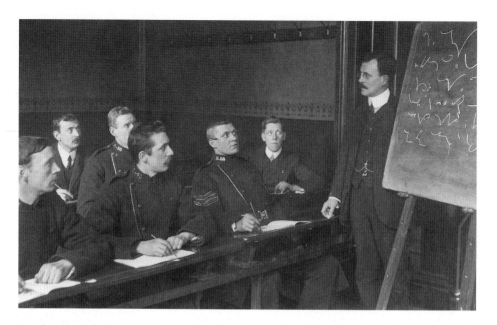

A rather puzzled sergeant stares intently at the sample of shorthand produced by the tutor in this Edwardian image. It is not certain how rigorous the teaching of shorthand was at this time – one officer's memoir recalled that the examiner gave each officer a sample shorthand text to copy out and duly passed everyone as being proficient in the taking of shorthand!

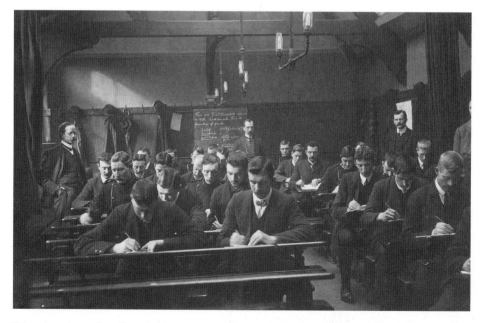

Education classes for officers held in the parade room of the Newton Street police station, now the Greater Manchester Police Museum. Special classes were inaugurated in 1899. As well as writing and arithmetic, police subjects such as law were also taught. Prior to this, training in the modern sense was almost non-existent, the new recruit merely being placed in the company of an older 'tutor' constable who showed him the beats.

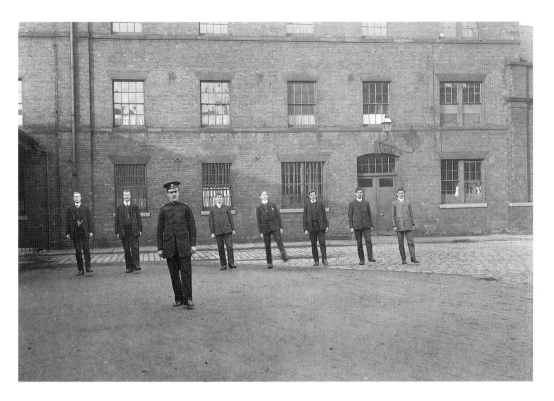

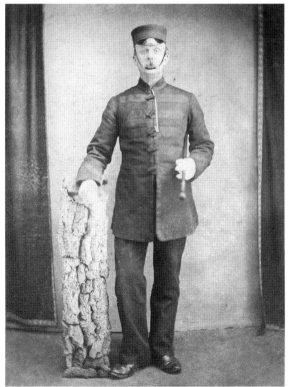

Above: A police inspector teaching new recruits how to slow march in the yard of Albert Street police station, off Deansgate, a year or two before the start of the First World War. Great emphasis was placed on marching and drilling the recruits, as well as teaching them to salute smartly.

Left: Inspector Palmer joined the force on 5 August 1880. Born in Nantwich, he was an upholsterer by trade. He was promoted to acting sergeant in 1900 and sergeant in 1902. By the end of 1903 he had made rapid progress to inspector, with a prospect of enhanced prestige and pension, but sadly he died of natural causes on 8 January 1906, aged forty-eight, less than three years after this photograph was taken.

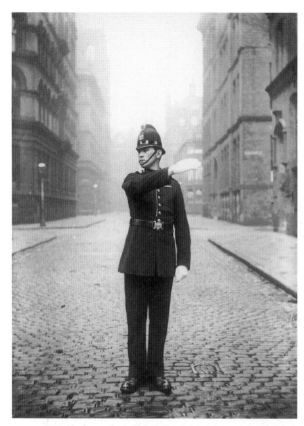

Left: A policeman on 'point duty' in Manchester, *c.* 1900. Before the invention of automatic traffic lights, police officers were a regular sight at all busy crossroads in towns and cities.

Below: A constable directs the traffic on the corner of Mosley Street and Princess Street in around 1910. Note the presence of the steam wagon (left). The drivers of the wagons needed to draw water from street hydrants from time to time and the wagons had to carry a badge showing the firm operating the vehicle had permission from the Corporation to take on water.

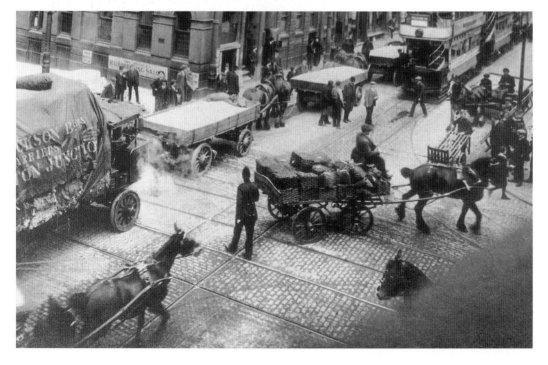

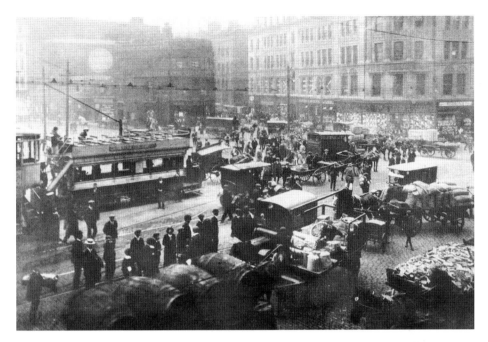

A view of Piccadilly taken in 1913 as part of a police report into the problems of traffic congestion in the city. In a bizarre experiment, the officers controlling the traffic in Piccadilly were withdrawn and two minutes later this photograph was taken of the ensuing chaos as trams, horse-drawn and motor vehicles all competed with pedestrians for safe passage through the streets.

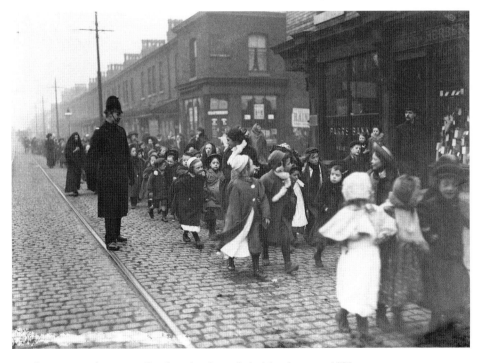

A policeman watches over a Sunday school parade in Manchester, *c.* 1900.

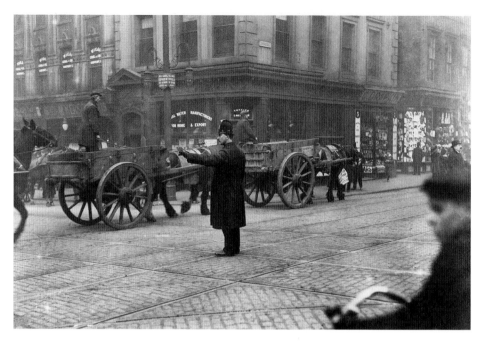

Point duty on a busy Edwardian city street. Officers were advised never to make horse-drawn vehicles stop suddenly at their junction, as it often led to an unfortunate reaction by the horse. One officer needed to be hosed down after his first tour of duty on Deansgate!

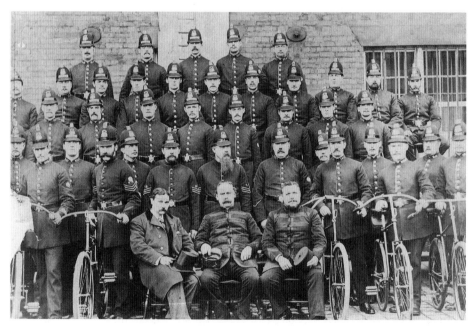

Police officers with their divisional cycles, pictured in the 1880s. At the centre of the front row is Inspector Joshua Sykes, a Yorkshireman who had served in the West Riding Constabulary before joining the Manchester Police. Note at this period the curious and short-lived habit of placing the numbers of the sergeants above their shoulder chevrons, rather than on the collar.

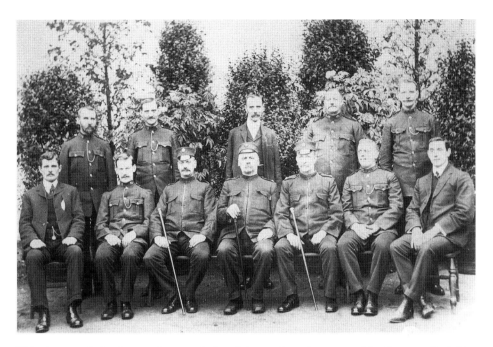

This photograph also features Inspector Joshua Sykes, again at the centre of the front row. Probably taken nearer his retirement date of 1909, it shows a change in uniform style compared to his earlier group picture. By this time, officers would be issued with notebooks, carried in a breast pocket.

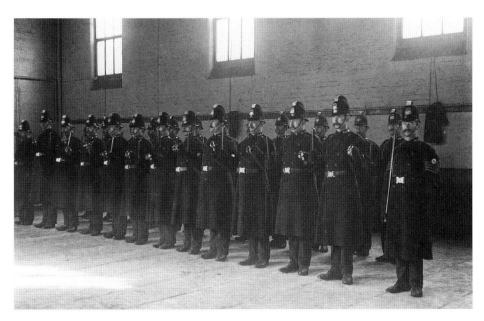

'Parading for Duty' around 1910. Before going out on the beat, officers would 'produce appointments', that is hold up for inspection their handcuffs, whistle, truncheon and at night a lantern. They would then be 'told off' by the inspector, who would read out any special notices and points of concern about the beats for that shift. On the right of the photograph can be seen the patrol sergeant, with his long walking stick.

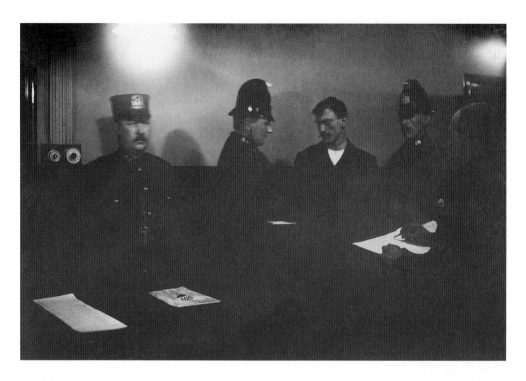

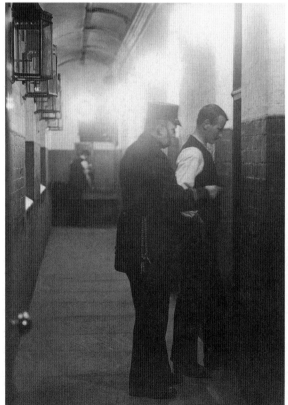

Above: In the Charge Office, *c.* 1908. Here we see a prisoner standing between the two arresting officers. Just visible to the right is the sergeant behind the counter, filling out the charge book. To the left of the picture is the Reserve Man, the officer who would take the prisoner through to the cells. On a chain suspended from his uniform is the key to the cells.

Left: A prisoner is locked in the cells – 'lagged and jugged' in nineteenth-century criminal slang. On the left can be seen the ornate gas lanterns which shone their light into the cells via a window over each cell doorway. No gas lamps were allowed inside the cells because of the risk of fire or explosion.

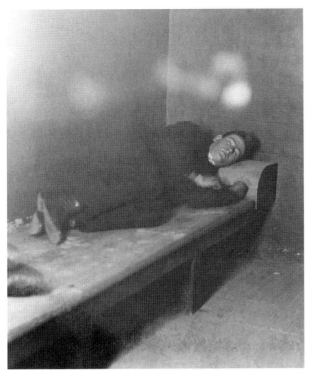

Left: A good night's sleep? A posed photograph showing a prisoner getting to grips with the cell's wooden bed and wooden pillow. Many stations had a 'drunk cell' in which the bed was only a few inches off the floor, ensuring that if the occupant rolled out of bed during the night, he would not injure himself.

Below: The Magistrates' Court, Minshull Street, Manchester. These courts would hear all manner of cases, with fines and short terms of imprisonment being handed out to thieves, brawlers and conmen. In this specially arranged image, we have the prisoner with his back to us in the dock, while on the bench at the rear of the court sit the magistrates. Over to the right can be seen a constable, taking the oath before giving his evidence.

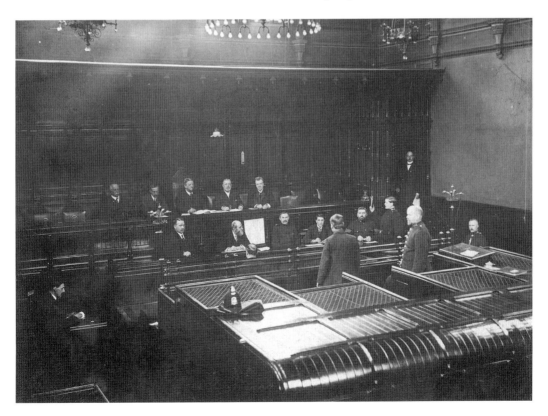

The solemn Manchester Coroner's Court, which for many years was accommodated on London Road. The building was also home to a main fire station and Whitworth Street police station

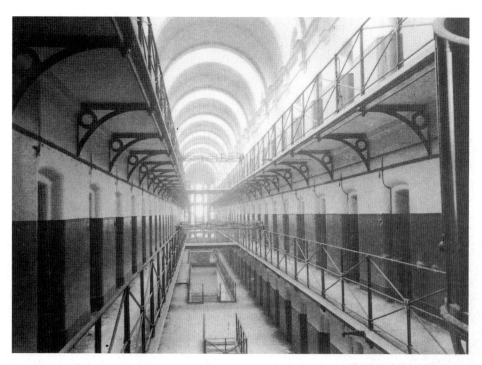

An interior photograph of a cell wing in the Belle Vue city gaol, Hyde Road, Manchester, mid-nineteenth century. The prison was in use until 1888 when it was demolished. Another gaol, the New Bailey, had been in use up to 1868 when it too was closed and replaced by Strangeways.

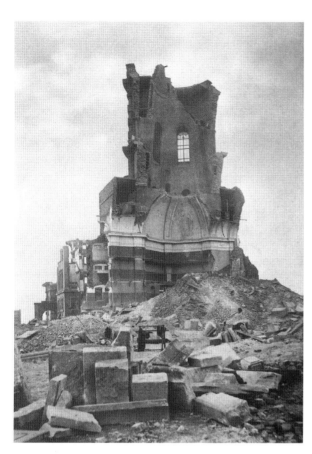

Left: The demolition of Manchester Gaol, Hyde Road, 1888, less than forty years after it opened.

Below: Manchester officers outside the gates of Strangeways Prison, *c.* 1900. It was the custom for the prison governor to put up a notice on the gates of the prison once an execution had taken place. Officers guarded the gates to make sure there were no disturbances by members of the public, the family of the executed person, or the family of the murderer's victim.

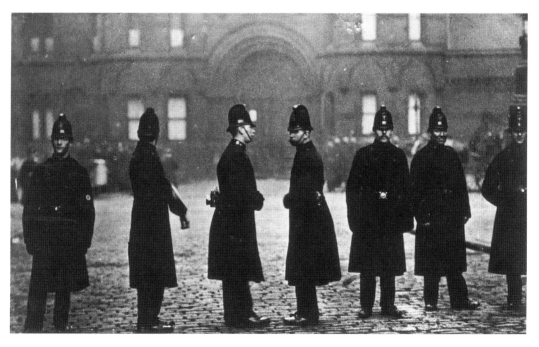

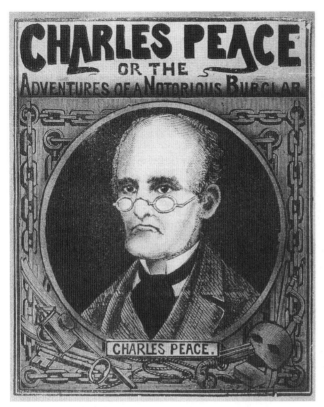

A Sunday school teacher and musician by day and an ingenious but ruthless burglar by night, Charles Peace only admitted to the murder of PC Nicholas Cock in Manchester while awaiting execution for another murder. Peace had shot the unarmed officer dead in 1876 when caught fleeing from the scene of a burglary.

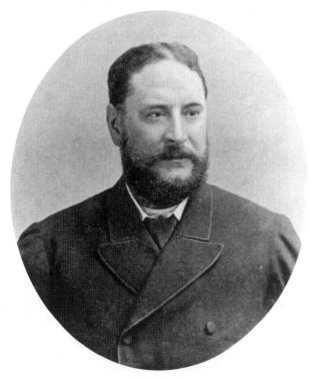

Jerome Caminada (1844-1914). As the nationally known head of detectives in Manchester, Superintendent Caminada's determination and ingenuity made him feared by the underworld, while his autobiography, *Twenty-Five Years of Detective Life*, highlighted his passionate concern for prison reform and the underprivileged of the city. A former engineering apprentice, Caminada was responsible for the imprisonment of 1,225 people during his career and brought about the closure of 400 disorderly drinking dens.

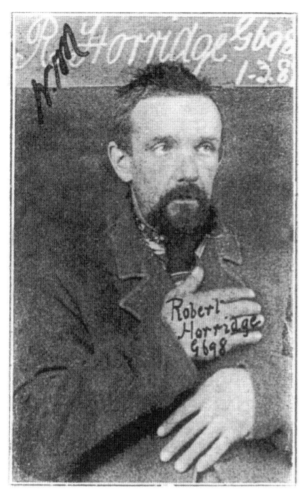

If Caminada was Manchester's 'Sherlock Holmes', Robert Horridge was the city's Moriarty. Over a twenty-year period he was repeatedly arrested by Caminada. Horridge was in trouble with the law from the age of thirteen and Caminada first met Horridge in 1869 when he was searching his house for stolen property. Horridge was sent to Dartmoor Prison in 1881. However, he managed to escape and was shot three times before being recaptured. A few weeks after his release in 1887 he was seen trying to break into a shop on Rochdale Road, Manchester. Constables Parkin and Bannon gave chase but he shot and wounded them with a revolver. He had acquired the gun for the specific purpose of shooting Caminada if he should try to arrest him again.

Caminada and his men, disguised as labourers, arrested Horridge in Duke Street, Liverpool. Horridge tried to reach his gun but Caminada had come prepared and drew his own revolver. Placing the muzzle to Horridge's head he said, 'If there is any nonsense with you, you'll get the contents of this'. Horridge went quietly at first but later tried to escape. Caminada drew his gun for a second time and hit Horridge over the head with the butt. Horridge stood trial at the Manchester Assizes and was sentenced to penal servitude for life. He never bothered Caminada again.

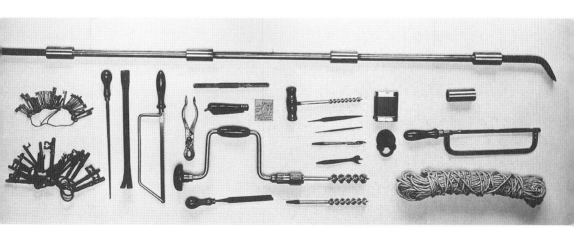

Included in this selection of housebreaking tools is a sectional jemmy, which could be unscrewed into shorter pieces, thus making concealment easier.

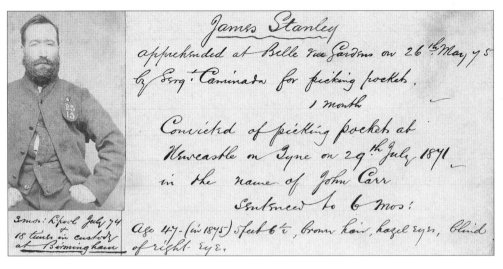

James Stanley, a pickpocket locked up by Caminada in 1875.

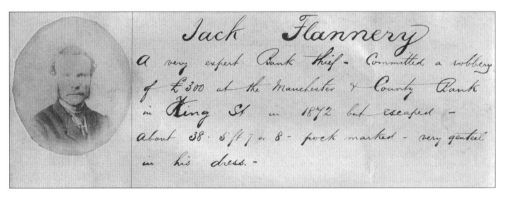

Jack Hannery, 'a very expert bank thief ... very genteel in his dress'.

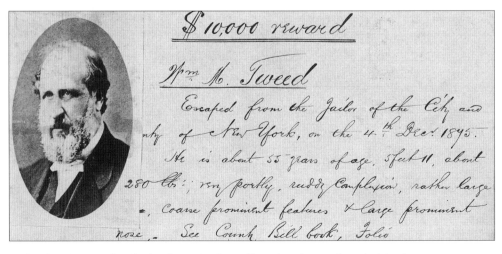

With a $10,000 reward on his head, New Yorker William Tweed was at large in Manchester.

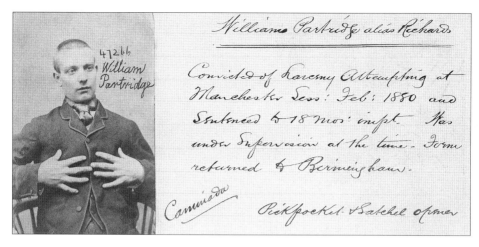

A pickpocket and satchel opener, known to Caminada. Note the hands placed across the chest, to indicate any missing fingers or thumbs.

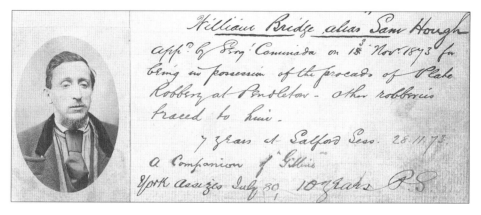

William Bridge, alias Sam Hough, another of Caminada's arrests.

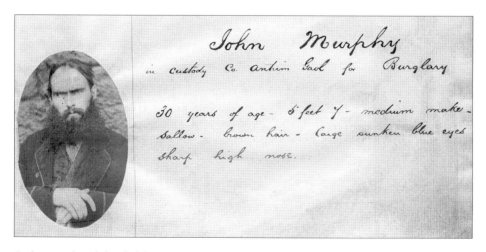

A photograph and detailed description of burglar John Murphy.

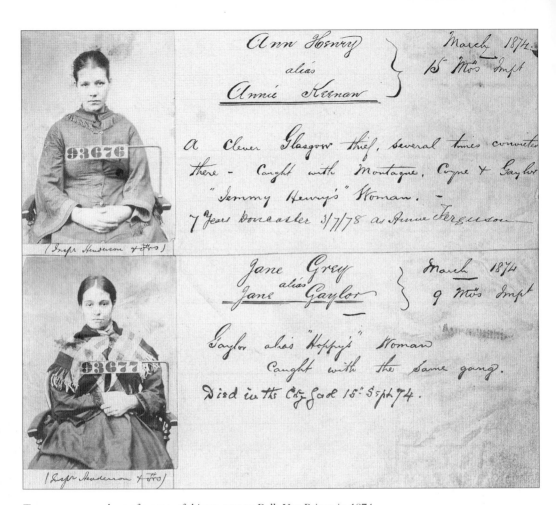

Two women members of a gang of thieves sent to Belle Vue Prison in 1874.

Opposite above: Teenager Edward Hughes was on the run from the Castle Howard Reformatory School.

Opposite centre: Notes on a man arrested for defrauding Dutch merchants of £1,200, but later acquitted.

Opposite below: With one leg shorter than the other, William Wiggins would have been easy to spot.

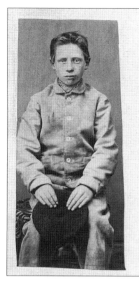

Edward Hughes -

Absconded from Castle Howard Reformatory 6 Dec. 187
7. 4ft 6 - light hair - light grey eyes - marked on
breast with a scald - (son of Mrs Hughes, Irene
Polisher, 5 Ward St Butter St, Oldham Road) -

Dirk Fraenewold Hoekzema -

Arrested by Inspr Henderson under Warrant
along with Jean Van Ommerow for an alleged
fraud of £1200 upon Dutch Merchants -
After protracted adjournments was acquitted

William Wiggins -

Committed for trial from Wigan for pocket
picking - a Charter St pickpocket -
one of his legs shorter than the other -
Been in Custody in Manchester often -
Got 3 mos on 8 Nov. 1869 - (Insp. Henderson & Co

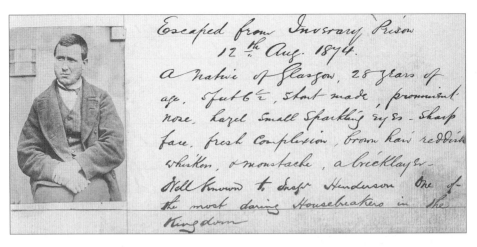

William Dixon, dubbed 'One of the most daring housebreakers in the kingdom'.

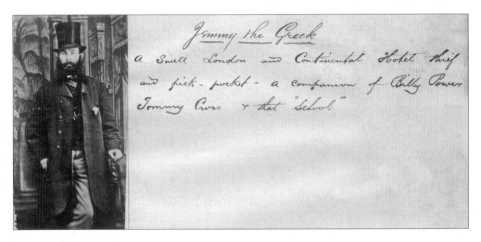

'Jimmy the Greek', a hotel thief.

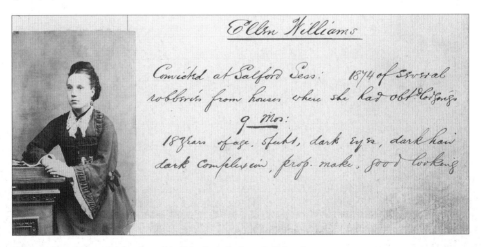

Ellen Williams, described as 'good looking', stole from lodging houses.

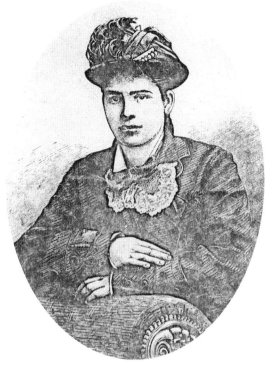

Left: Sarah Jane Roberts, a servant murdered in Harpurhey in 1880. At the time of her death there was speculation that her eyes would have recorded the image of her murderer on the retina, much in the way an image was captured on a photographic plate. Incredible as it seems, Mr Mudd, a surgeon based in St Ann's Square, Manchester, was requested to scientifically examine Sarah's eyes for traces of an image, which, needless to say, could not be found.

Below: Officers investigate a case of arson, Rusholme, early 1900s.

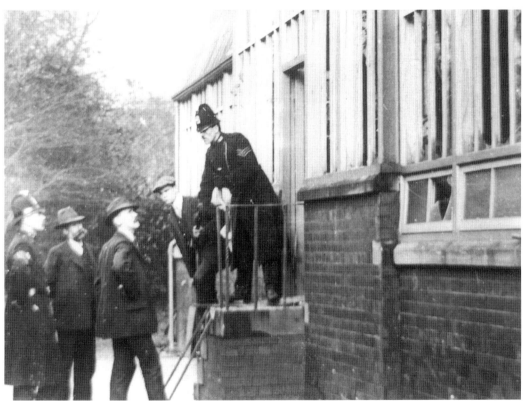

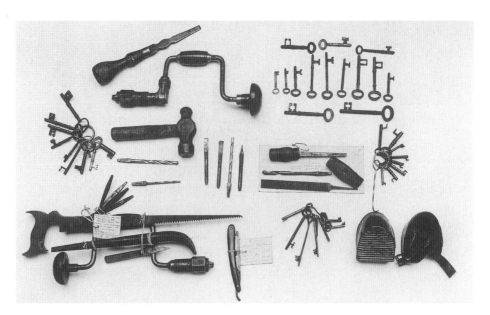

Burglary tools seized by police in Manchester, *c.* 1900. At this time breaking in at night was classed as burglary and carried a stiffer sentence than housebreaking or shopbreaking, which was carried out during the day.

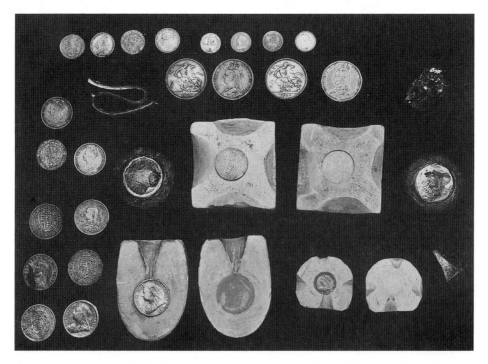

Items from a coiner's workshop. Real coins were used to make plaster of Paris moulds and then fake coins were cast in the moulds using a soft metal such as lead. The coins were then aged by scrubbing and staining. The best-quality counterfeits, made of brass with a silver or gold coating, would ring if dropped on a hard surface and were difficult to detect when new.

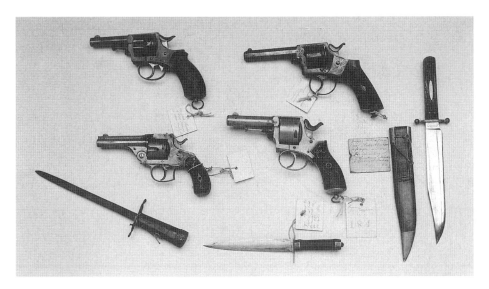

This selection of revolvers and knives taken from Manchester criminals in the 1900s dramatically illustrates the dangers faced by the unarmed police force. At this time, many householders kept a pistol at home in order to protect themselves from an armed burglar.

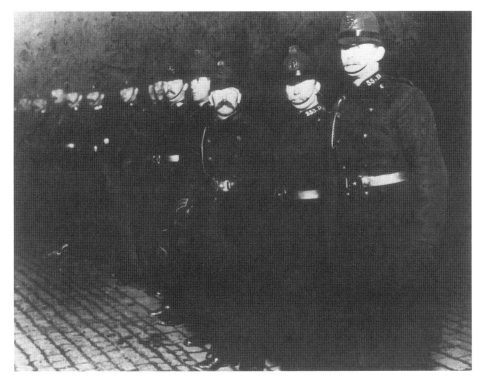

Officers parading for night duty, early twentieth century. Notice the blacked-out helmet plates. Officers were encouraged to walk on the outside edge of the pavement during the day in order to be visible to the public but at night they were instructed to walk in the shadows to catch criminals by surprise. The black helmet plates helped them to become invisible.

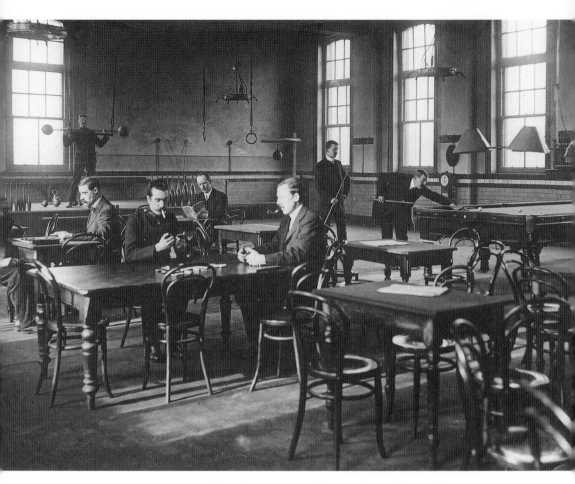

Mill Street police station recreation room on the C Division (east of the city centre), *c.* 1911. In this year, there was one superintendent, eleven inspectors, thirty sergeants and 206 constables working from this division. Note the officer at the back of the room weight training.

Opposite above: Superintendent Alexander Hornsby commanded in turn both the C and D Divisions at the end of the nineteenth century. Originally from Winchcombe in Gloucester, Alexander was a labourer before joining the force in June 1868. His aptitude or daring appears to have led to rapid promotion straight from constable to detective inspector and then to superintendent!

Opposite below: A Manchester City Police superintendent patrols his division in the Castlefield Road area, *c.* 1900. As well as being responsible for every officer and incident on his division, the superintendent was expected to be accessible to members of the public and respond to complaints. He was also responsible for inspecting the police stations on his division, to ensure they were kept clean and in good order.

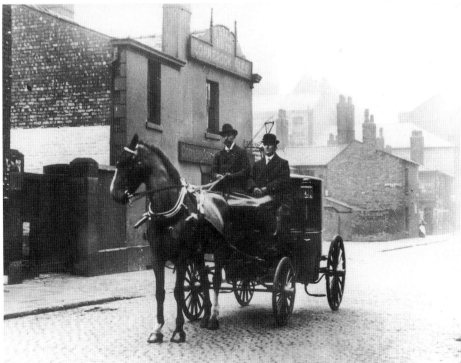

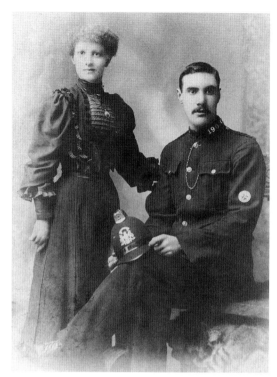

Left: Joseph Blain poses with his wife soon after he joined the police in 1905. A travelling salesman from Manchester, Joseph worked hard and secured promotion to sergeant and then finally inspector on C Division in the east of the city.

Below: The Manchester City Police Band, *c.* 1908. The band was formed in 1877 and usually comprised officers from the A Division (city centre) who practised during their day shift. The police band played a wide selection of music and attended many public functions, often leading processions through the city centre.

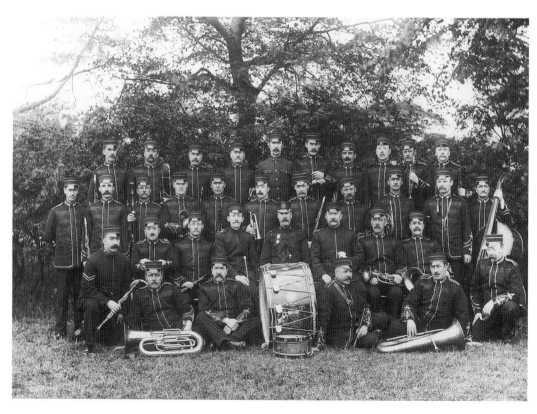

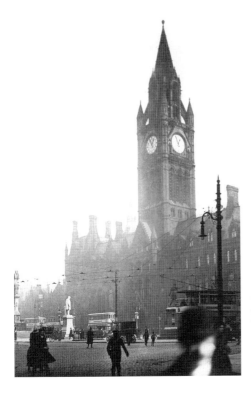

Manchester Town Hall. Built in 1877, this magnificent structure housed not only the seat of local government, but also police headquarters and accommodation for the chief constable and the Watch Committee – the council committee that supervised, among other things, the work of the police.

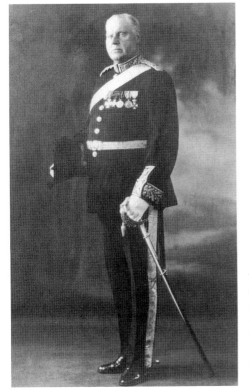

Chief Constable Sir Robert Peacock. He served the people of Manchester for twenty-eight years as chief constable, until his death in 1926. Described by the *Manchester Guardian* as the doyen of chief constables, Peacock was the first head of the Manchester Police who had worked his way up through the ranks and had served in several other forces. He had been chief constable in Oldham before coming to Manchester in 1898.

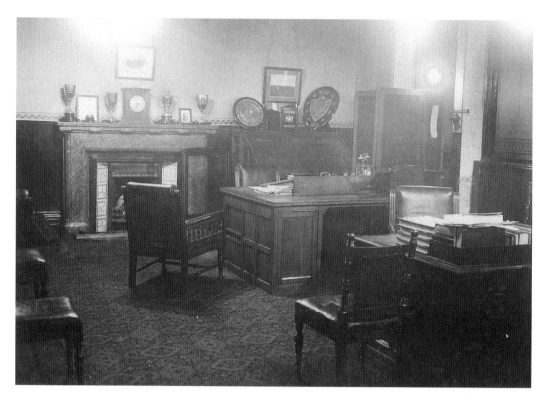

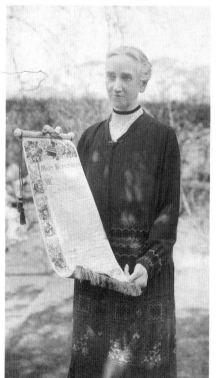

Above: The chief constable's office in the Town Hall around 1910.

Left: Miss Mary Hopkinson was known for more than sixty years as the 'Fairy Godmother of the Manchester Police', devoting her life to police benevolent work. She started a local branch of the International Christian Police Association in Manchester in 1885 and founded the Manchester and Salford Police and Fire Brigade Benevolent Fund. She died in 1951 aged ninety-four.

Opposite above: Under the statue of Oliver Cromwell on the approach to Exchange Station, an eager crowd awaits the arrival of King Edward VII, who came to Manchester in 1909 to open the new Royal Infirmary on Oxford Road.

Opposite below: Edward VII at the Royal Infirmary on Oxford Road in 1909. The infirmary had originally been located in Piccadilly, but had outgrown the site. The King was so impressed by the facilities of the new hospital that he knighted the hospital chairman, William Cobbett, on the spot. The King is seen here leaving the hospital by car, observed by nurses and police officers.

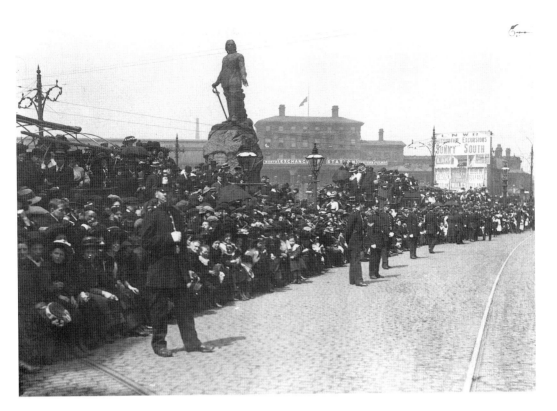

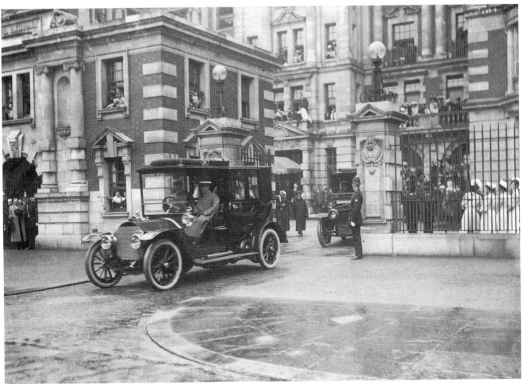

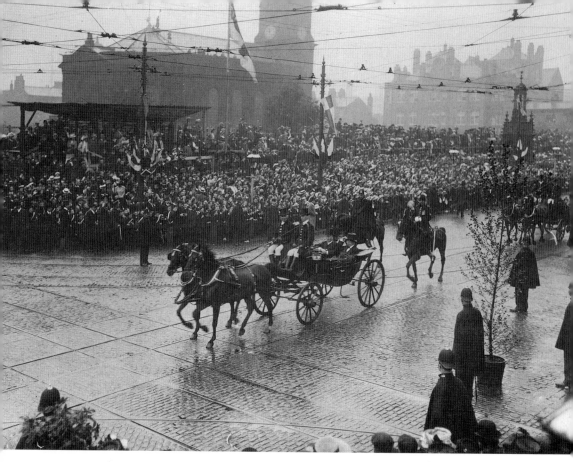

The Chairman of the Watch Committee – the council body responsible for policing in the city – takes part in the official procession marking Edward VII's visit to Manchester in 1909. Notice the police officers are wearing capes over their tunics – a sign of inclement weather.

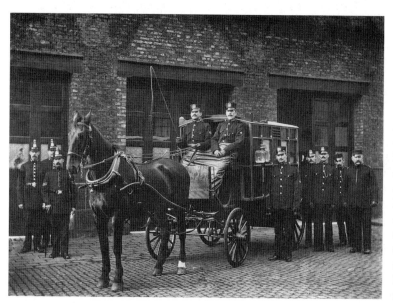

The Manchester Police Horse Ambulance, pictured outside Goulden Street police station, c. 1908. In 1900, Chief Constable Robert Peacock decided that four ambulances should be provided, one on each division, and that each station housing the ambulance should be equipped with a telephone.

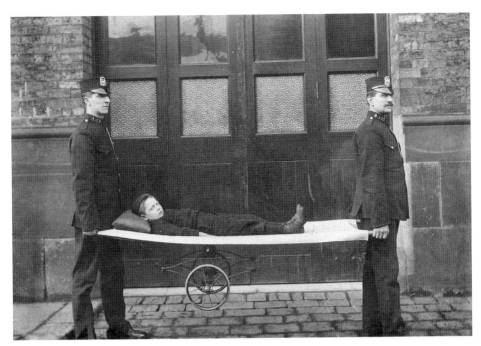

A Horse Ambulance 'litter' or stretcher, *c.* 1908. This stretcher was designed to fit neatly in the back of the ambulance. However, before the introduction of the Horse Ambulance in 1895, stretchers similar to the one shown were the only method of transporting the sick, injured or dead to the hospital or mortuary.

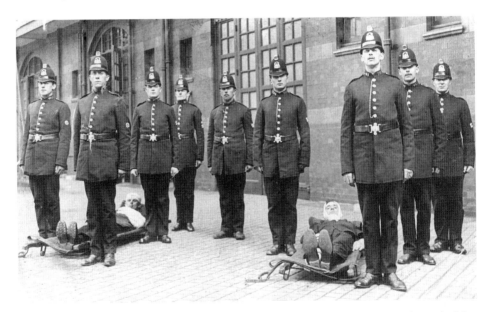

Manchester police 'Stretcher Drill', *c.* 1910. This photograph was probably taken in the yard of the London Road fire station, which was also the site of the Police Training School. Second from the left is PC Arthur Horgan, later killed in action in October 1917. All officers are wearing a St John Ambulance badge on their upper left sleeve.

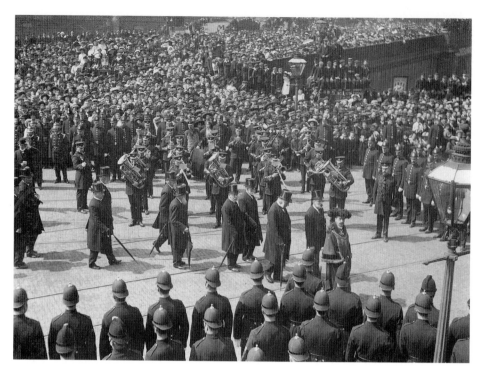

The Mayor and civic dignitaries attend a service at Manchester Cathedral to mark the funeral of King Edward VII in 1910.

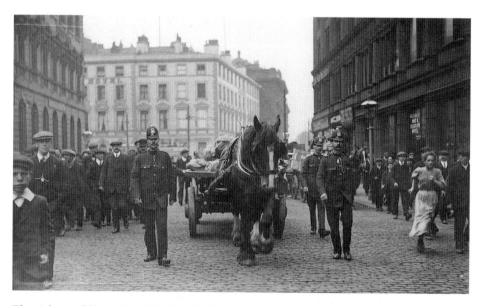

The violent and bitter Carter's Strike of 1911 nearly brought Manchester to its knees because it slowed down food supplies reaching the city centre. At one point Mounted Police officers were forced to draw swords on a rioting mob, and the police had to escort the carters who carried on working to ensure that they were not intimidated. Here the police provide protection for a carter travelling from Piccadilly Gardens along Newton Street.

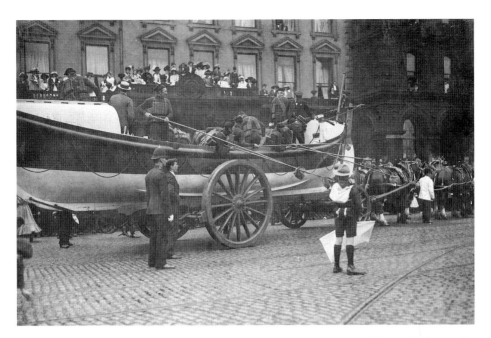

The annual Lifeboat Sunday procession in Manchester just before the First World War. The long poles held out from the boat have nets at the end and are used to gather in cash donations for the Lifeboat Fund, while a policeman and a Boy Scout with signal flags stand ready for the procession to move on.

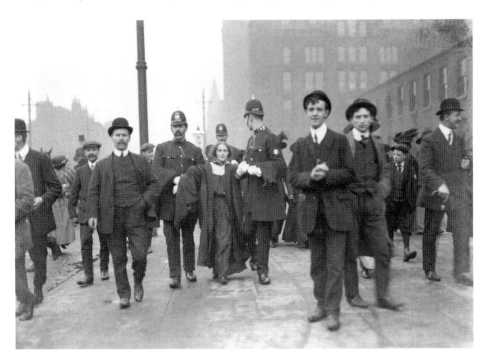

City police officers arrest a suffragette after a demonstration outside the gates of Manchester University, *c.* 1908. The Women's Social and Political Union had been founded by Emmeline Pankhurst only a few years before in 1903.

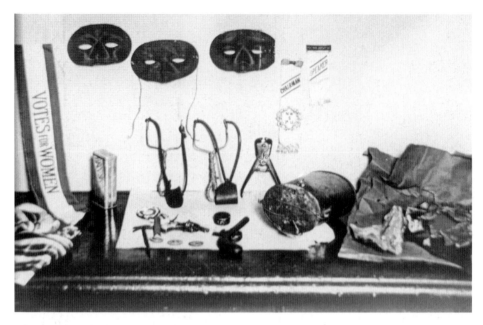

Above: Masks and other paraphernalia recovered during the suffragette protests in Manchester. Some members of the movement were prepared to use violence to get 'Votes for Women', often resorting to terrorist-style methods. A number of buildings were destroyed by fire in and around Manchester.

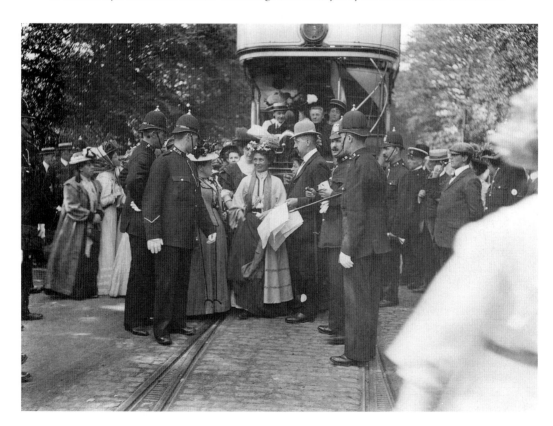

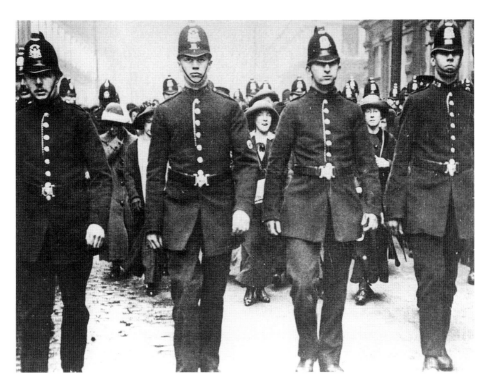

Escorting a suffragettes' protest march through Manchester, *c.* 1910.

Above: Manchester City Police Cycle Corps divisional dispatch riders. Lined up for a HMI (His Majesty's Inspector of Constabulary) visit, pre-1914.

Opposite below: Emmeline Pankhurst and supporters in Heaton Park, Manchester, *c.* 1908. Emmeline is attempting to obstruct the tram, one of the more peaceful demonstrations in the history of the suffragette movement. The police didn't quite know how to react to the suffragettes; a word often used was 'bemusement'.

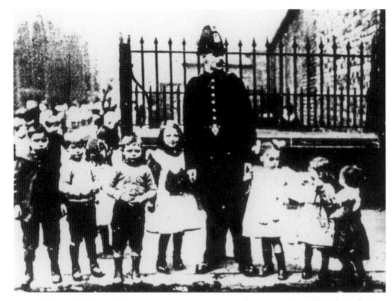

A Manchester City Police constable on school crossing patrol, 1914. Although this was a good opportunity for police officers to meet the local community, the officers often resented it because it took them away from their beat duties.

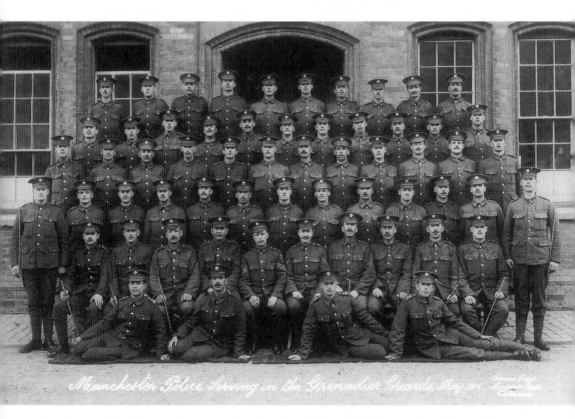

Manchester police officers serving in the Grenadier Guards, May 1915. Many regular officers left the police force at the start of the First World War to join local regiments. In response to this, special constables were enrolled in great numbers. After the war, many soldiers returned to the police and all special constables received a decorated truncheon in appreciation of their services.

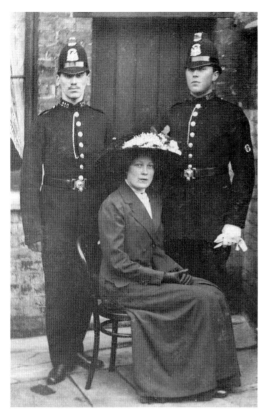

Literally brothers-in-law, Constable George Millington (left) poses with his wife Ellen and brother-in-law Constable Sam Whittle in the years leading up to the First World War. Both George and Sam resigned in order to enlist in the armed forces in 1915. George rejoined in April 1919 and retired in November 1935. Sam, on the other hand, seems to have had no desire to return to policing after the war and disappeared from police records.

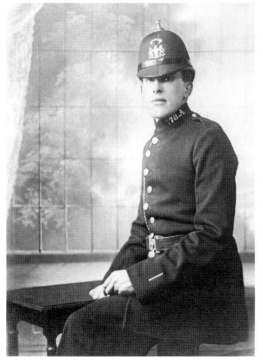

PC Ernest George Stagg joined the police on 25 May 1914 aged nineteen and a half. He responded patriotically to the call for volunteers to replace the terrible casualties of the first months of the First World War and resigned the force in January 1915. At 6ft 2in he was an ideal candidate for the Grenadier Guards. He was able to rejoin the police in January 1919 and was pensioned in 1941.

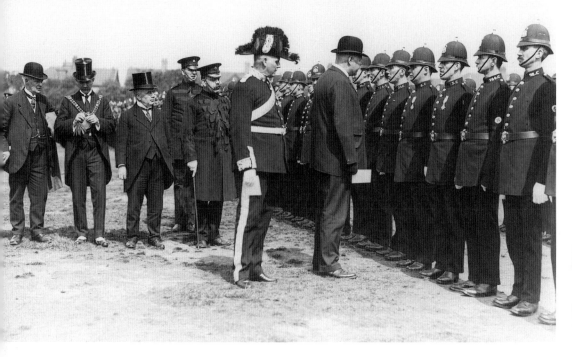

The annual inspection parade of 1919. On the left we have the Lord Mayor and two members of the Watch Committee, then, standing tall in his peaked cap is an inspector, while in front of him, stick in hand, is a superintendent in his braided frock coat. In his distinctive ostrich-plumed hat is Chief Constable Sir Robert Peacock. Addressing the constables is one of His Majesty's Inspectors of Constabulary.

three

The
Inter-War
Years

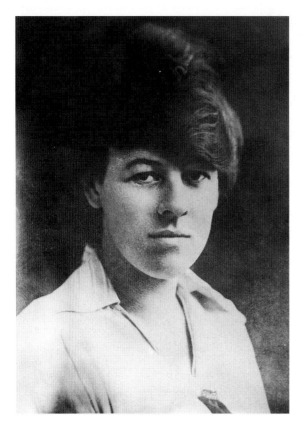

Left: Clara Walkden was the first sworn-in woman constable in the Manchester area. She joined Oldham Borough Police in May 1921. In the same year nine women were engaged as 'unofficial' police officers in Manchester. Their duties included supervising female common lodging houses, obtaining evidence in licensing and fortune-telling cases and making enquiries into reports of deserted wives, missing women and assaults against women.

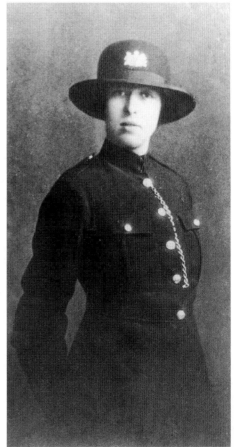

Right: Ann Ashton was the second policewoman to join the Manchester force in 1921. The first female officers did not have the power of arrest.

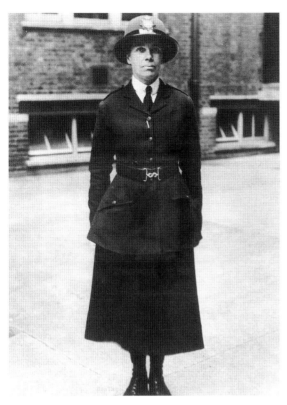

Inspector A. Clayden was the Chief of the Women's Police Department in Manchester, mid-1920's. By 1931, policewomen had to be either unmarried or a widow, between twenty-two and thirty-five years old and not less than 5ft 4in in height. The Women's Auxiliary Police Corps was set up in 1939 to serve alongside the regular women's police force.

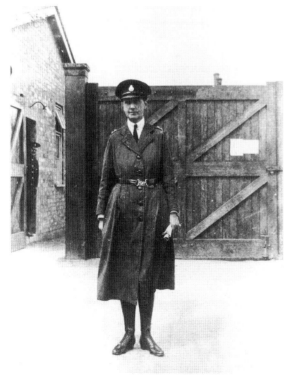

The few women police officers to venture into an otherwise male-dominated profession were regarded with suspicion by most of the service. It would take many years before they gained acceptance.

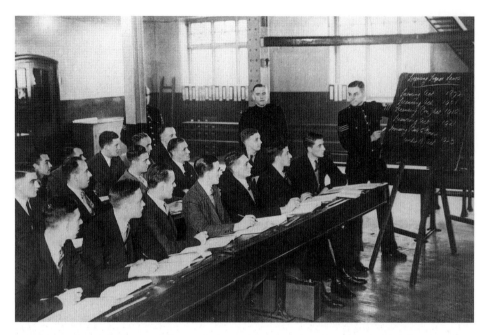

Manchester City Police training class on liquor and licensing laws, *c.* 1920. In 1927, Manchester Police saw 2,845 offences of drunkenness with aggravation.

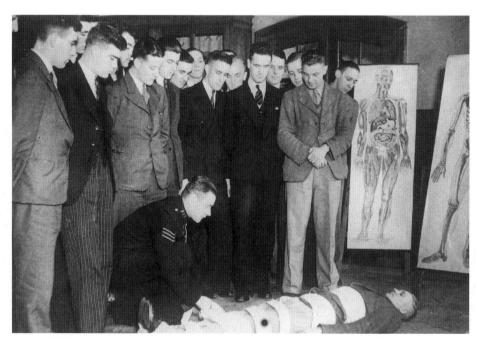

Officers learn the art of first aid at Manchester Town Hall, 1923. By 1927, 1,050 members of the Manchester Force had a St John Ambulance certificate and in the same year first aid was rendered to 3,212 people who had met with accidents or had been taken ill in public places.

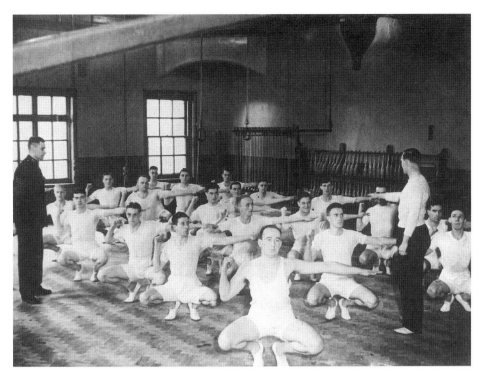

Physical education training for the police, Manchester Town Hall, *c.* 1924.

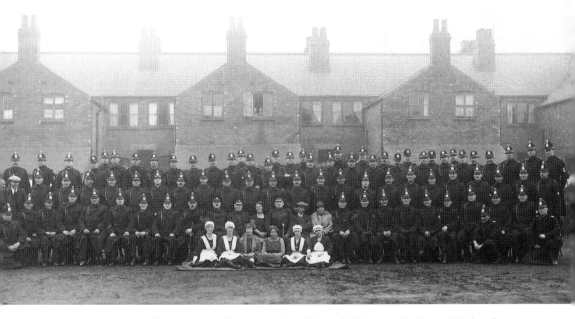

A group photograph of Manchester police stationed at Chesterfield during the General Strike of 1926, performing what was called Mutual Aid Duty. It appears that the domestic staff from the officers' lodgings have also been invited to appear in the photograph.

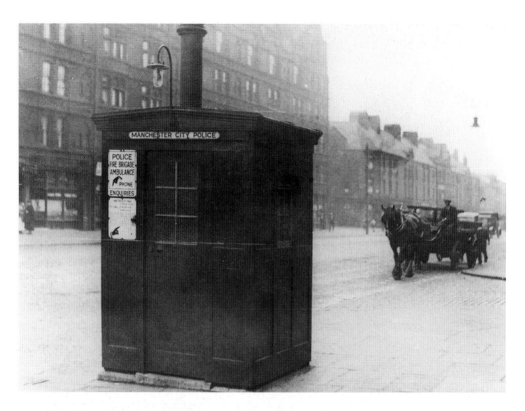

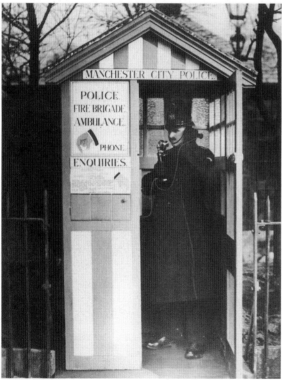

Above: The police telephone box at the corner of Oldham Road and Thompson Street. Introduced in the late 1920s, it was planned to replace older police stations with a network of boxes, each with a telephone for use by the police or the public. Officers would patrol from box to box, and could use the interior for writing reports and meal breaks. The public could use the telephone to request the attendance of the police, fire or ambulance services.

Left: PC Harry Knowles makes a call from Manchester's first police box at Ben Brierley on Moston Lane, Moston, 1928.

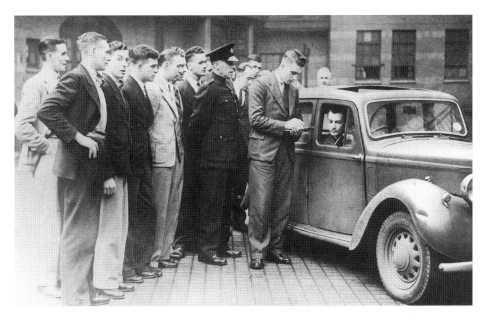

Probationary constables look on keenly during a 1930s training session in the yard of the fire station at London Road. The trainer is an acting inspector, as shown by the now obsolete rank badge of one star on his shoulder, as opposed to the two stars of a full inspector.

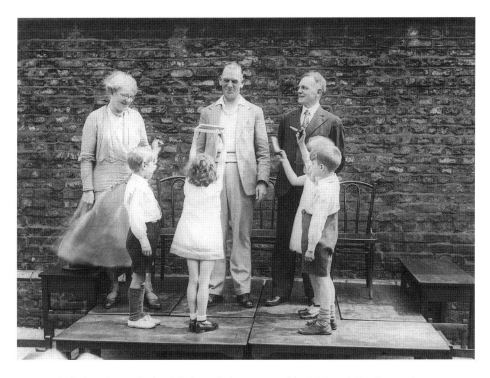

On a makeshift podium of school desks and chairs, Constable C7 Joseph Fowler receives retirement gifts from local schoolchildren in 1933. Born in Preston, PC Fowler had already served in the Lancashire police for nearly two years before transferring to Manchester in 1909.

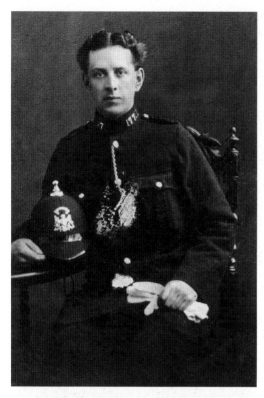

John William Ashton, constable with Manchester City Police from 1920 to 1950. By this time, the police service was seen as a career and a constable's service was typically between twenty-five and thirty years.

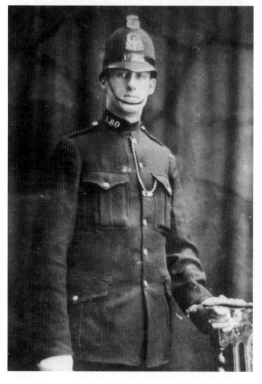

PC Sid Statham, Manchester City Police, in 1931, one year after he joined the force. Unlike the neighbouring Salford City Police, Manchester did not systematically take photographs of its officers. Most portraits such as this would have been taken privately at the officer's own expense.

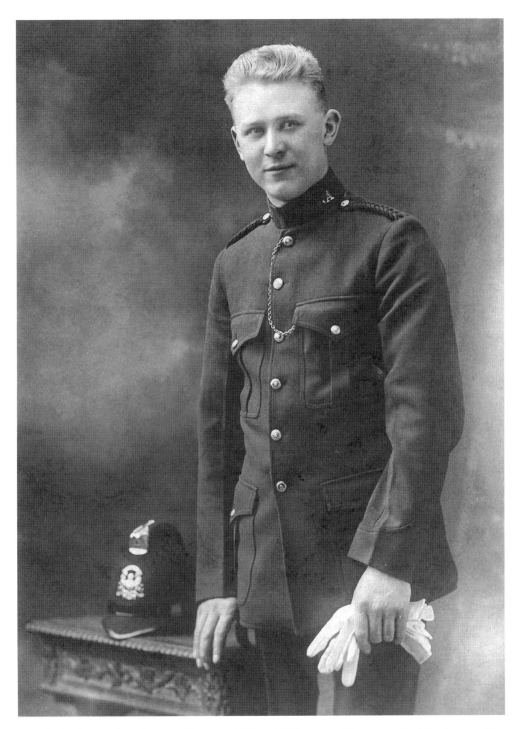

PC Alfred Edgar Bridge, who served between 1928 and 1958, was well known to the Manchester public as the point duty man on Blackfriars Bridge. The same officers controlled certain junctions for many years and commuters got to know their individual styles. Some directed traffic with stiff, clockwork movements while others gave subtle instructions with their white-gloved hands.

Cumberland-born Constable William Henry Young, seen here in 1920, wears his double-breasted greatcoat, a formidable item of uniform. In winter an officer would first put on a heavyweight tunic, then his greatcoat. Over the greatcoat was finally placed his cape, made of thick wool felt, called Melton. The difficulties of chasing fleeing burglars over walls and through hedges while dressed in so many layers can easily be imagined.

Police Constable Thomas Jewes. He died in June 1933 while trying to save the life of a man who, according to two witnesses, was under the influence of alcohol. William Burke – an ex-boxer – was hanging over Victoria Bridge trying to rescue a cat when he lost his grip and fell into the River Irwell. Constable Jewes immediately took off his cape and helmet and dived into the river. Burke disappeared under the water as Jewes tried to reach him. Tragically, due to the cold, Thomas also went under the water and both men drowned. In the meantime the cat had been saved from the bridge. During the inquest, it was claimed that Burke and his friend had deliberately put the cat on the bridge, intending that Burke could rescue it in front of crowds of people, and then collect gratuities from them for his courageous act.

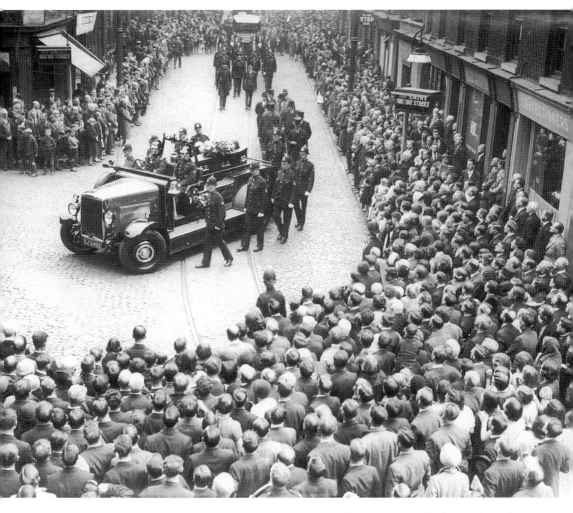

The funeral of Thomas Jewes was one of the largest seen in Manchester. Crowds fell silent as the coffin, carried on a fire tender, left Albert Street police station. (By permission of the *Daily Mail*)

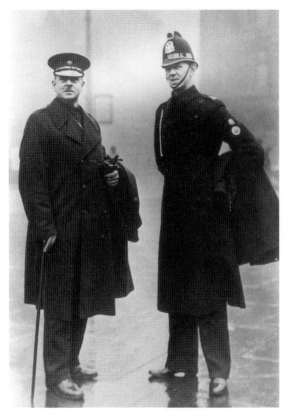

Constable Les Stephenson (pictured right) with his inspector. Les was a close friend and colleague of Thomas Jewes. He arrived at the scene of the accident minutes after Thomas disappeared under the water. He pulled Thomas from the water but could not revive him. A few years later, Les Stephenson married Thomas Jewes' sister.

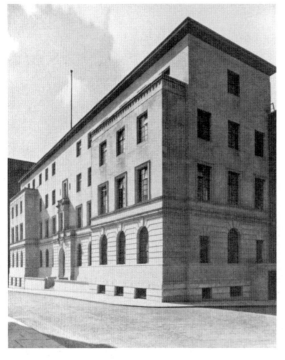

The new Manchester City Police Headquarters, located on Southmill Street, was officially opened on 16 July 1937. Built at a cost of £100,500 it possessed hydraulically operated lifts and housed a variety of specialist departments, such as the criminal record office, the motor taxation office, scientific laboratories, the identification parade room, a school room, and a gymnasium, as well as a charge office and eight cells.

four

Wartime
Policing

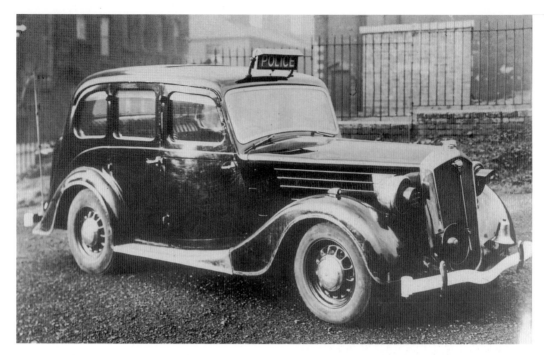

A Wolseley prepared for wartime use, *c.* 1940. Notice the covers over the headlamps and the white tape around the running boards and bumpers.

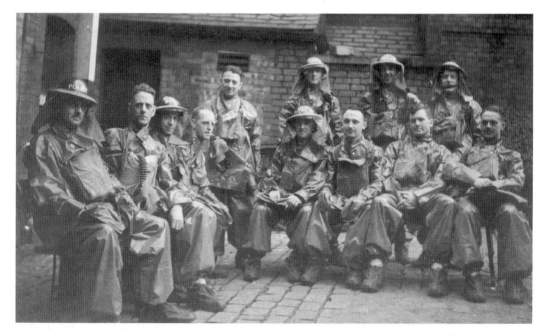

A group of police officers rest following their anti-gas training in the run-up to war in 1939. The police were issued with cumbersome oilskin anti-gas overalls, complete with a hood-like extension that fitted around the wearer's steel helmet and respirator. Fortunately for all concerned, these suits were only worn on training exercises.

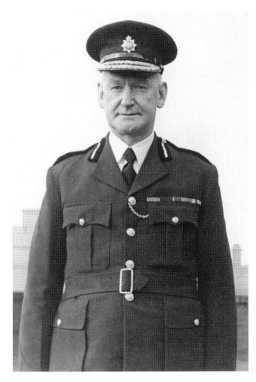

Left: Chief Constable Sir John Maxwell forged a unique police career in Manchester, joining as constable and retiring as chief constable, having never served outside the city. His period in charge saw the introduction of a police radio network and the creation of forensic science laboratories. He also led the force during the terrible bombing of Christmas 1940. He retired in 1942, exhausted by the strain of wartime duties.

Below: In 1940 the Manchester Police made an historic decision to swear in six women as police constables. They can be seen here in the front row of this inspection parade held at Bootle Street police station.

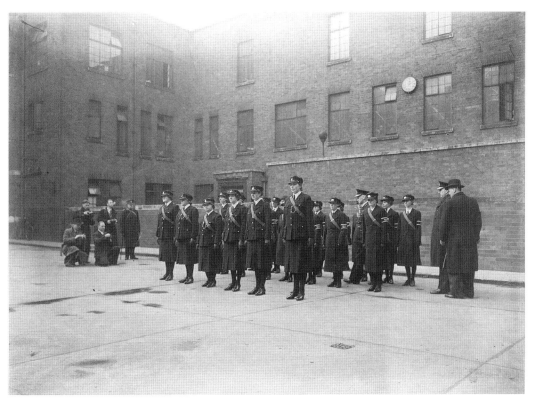

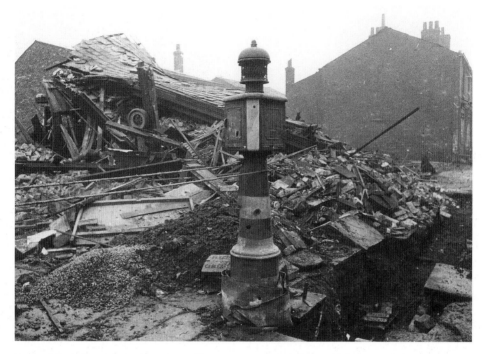

Battered but still standing, the police pillar on the corner of Oldham Road and Butler Street seen after an air raid. Introduced in the 1930s, these cast-iron pillars contained a two-sided cabinet at the top of the structure. On one side was a public speaker system while the other had a telephone for police use.

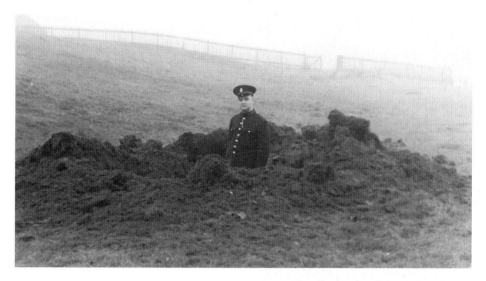

A glum-looking PC Harry Martin poses in a bomb crater in Heaton Park, to show the size and scale of the impact. Air forces on all sides claimed to be able to bomb with great accuracy, but research into the results of actual raids revealed that many bombs landed miles from the target in open country. Sometimes police damage collators were unable to even determine what the intended target of a particular raid had been.

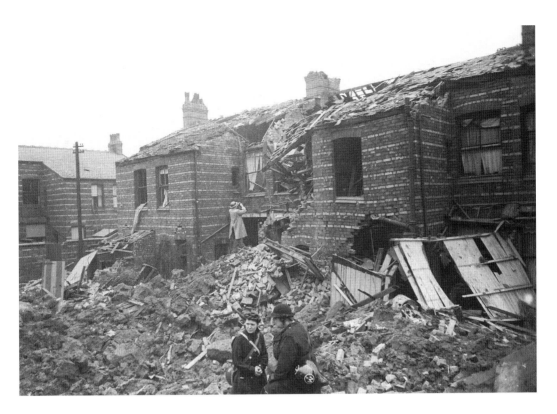

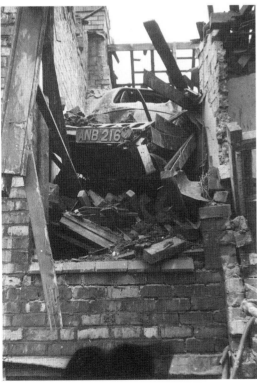

Above: In the centre of this photograph in raincoat and hat can be seen Mr E.B. Pemberton, one of the Manchester Police wartime photographers. The setting is Yew Tree Avenue and he is recording a remarkable occurrence – a motorcar that had been blown into a bedroom by the explosion of a nearby bomb.

Left: A close-up of the incident on Yew Tree Avenue showing the car embedded in the upper floor of the house. Bomb blast could produce a variety of unusual effects, channelled in different directions by buildings.

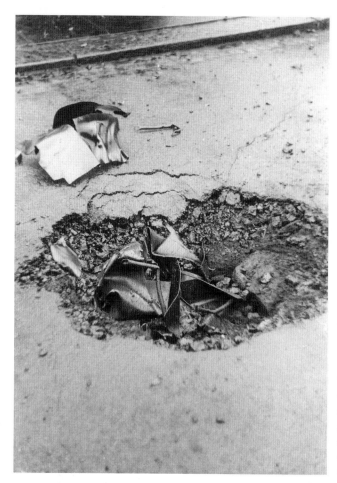

An unexploded heavy incendiary bomb, known to the police and air-raid wardens as an oil bomb, as found on Ferndene Avenue, Withington. Such photographs were used in the training of civil defence workers and rescue squads, helping them to recognise the wide variety of dangers that they faced when digging out trapped survivors.

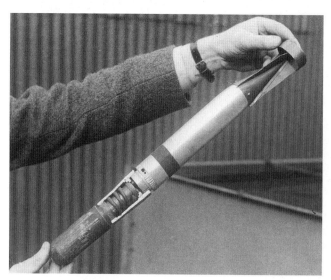

A police photograph of the German anti-personnel incendiary bomb. Incendiary bombs were designed to ignite on impact and start fires. Fire Watchers hoped to put out the bombs before the fire had taken hold. This demonstration item has been sectioned to reveal its secret explosive charge. On impact this modified bomb began to ignite as normal, but then a few seconds later the explosive charge went off, which would kill anyone trying to tackle the firebomb. The Germans hoped that Fire Watchers would delay tackling incendiaries, thus giving more time for the fire to spread.

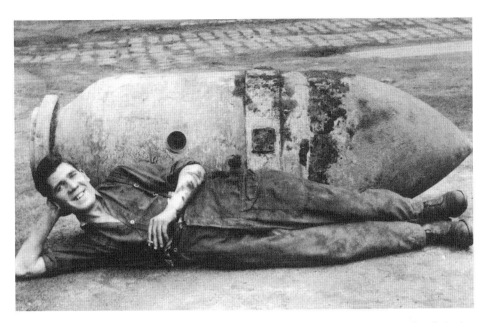

A member of a Bomb Disposal crew relaxes in front of a disarmed, unexploded German bomb. As the war progressed, bombs with timer devices were dropped, so as the crew began to dig carefully down to the bomb as they could not know whether it was a 'dud' or one that could explode at any moment.

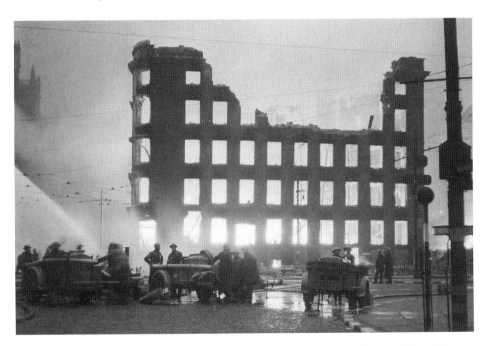

Fire tenders in Parker Street, Manchester city centre at the height of the Christmas Blitz 1940. The fires were such that help was needed from brigades all around Manchester, but the variety of equipment used by these different services sometimes led to delays and inefficiency. To overcome this countrywide problem, the fire service was nationalised on 18 August 1941 and procedures and equipment were standardised as much as possible.

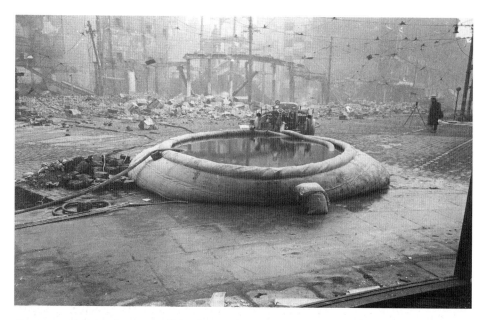

A common sight on the streets of Manchester after a raid – an inflatable emergency water tank set up by the fire brigade. During the Christmas Blitz, with water mains smashed, it was feared that buildings would have to be deliberately destroyed to create firebreaks, to stop flames leaping from street to street across the city centre.

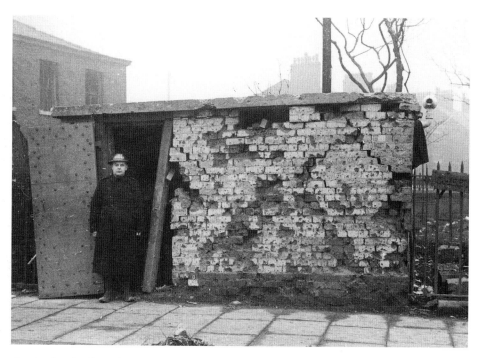

A grim-faced police officer stands in the wrecked doorway of an air-raid warden's post, after a near miss from a bomb. The pockmarked walls and the heavy door blown from its hinges testify to the ferocity of the explosion.

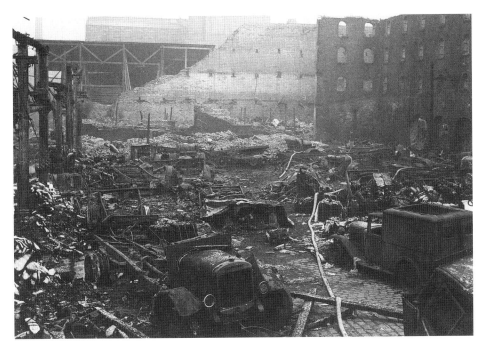

Lorries and other commercial vehicles lie burned out in the smouldering wreckage of C.T. Faulkner & Co. Ltd, one of over 200 businesses destroyed during the Christmas Blitz of 1940.

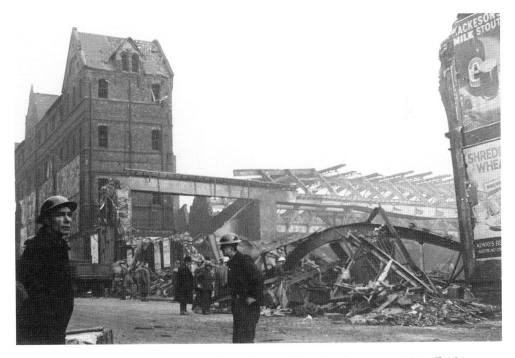

Civil Defence personnel wait anxiously in front of bombed Victoria railway station. This official image, one of several recording the damage to the station, would not have been published at the time, in case German Intelligence obtained a copy and used it to verify the accuracy of their bombing raids.

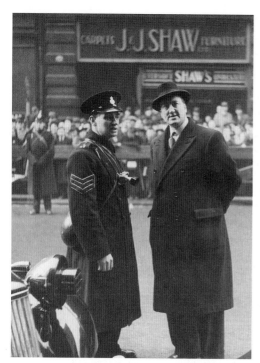

Left: Sergeant John Easton, one of the team of official police photographers, waits for the arrival of the King and Queen during an official visit to Manchester. Note the hooded vehicle headlamp in the foreground, complying with blackout regulations.

Below: Constable Victor Brookes acts as chauffeur to Sir Winston Churchill for one of the Prime Minister's morale-boosting visits to the Manchester area during the war. Given the often temperamental nature of pre-war motorcars, the Prime Minister would have been reassured to learn that PC Brookes had originally trained as a motor engineer before joining the police transport section.

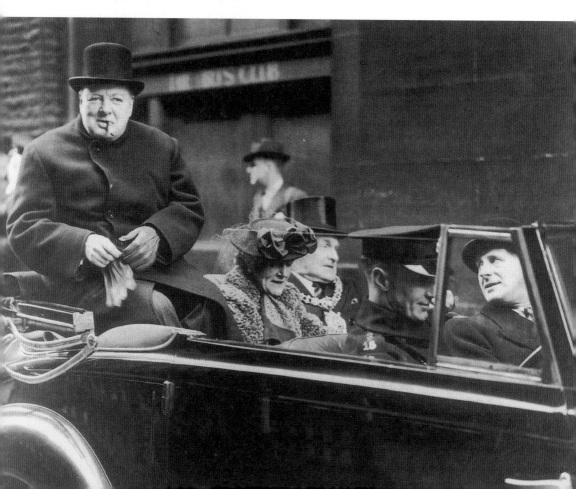

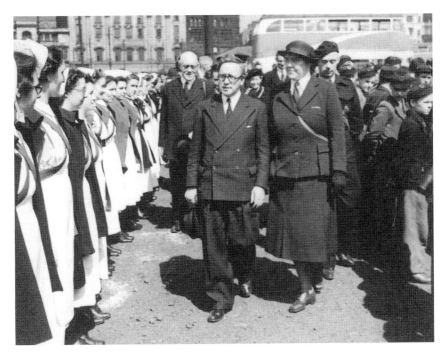

Above and below: Nurses prepare to meet Home Secretary Herbert Morrison on his visit to Manchester on 6 May 1942. Assembling on open ground in bombed out Piccadilly, Mr Morrison addressed representatives of the many civilian organisations that worked tirelessly on the Home Front. Air-raid wardens, civil defence workers, schoolboy messengers, Red Cross and St John Ambulance staff were among many groups who marched past at the conclusion of Herbert Morrison's inspection.

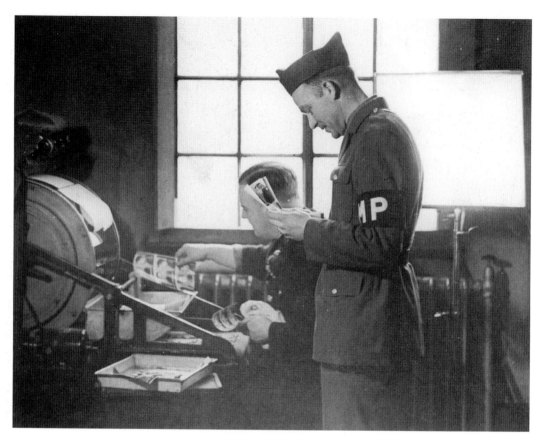

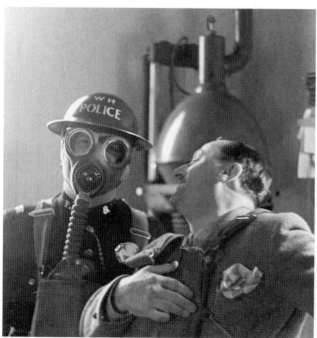

Above: A United States Military Policeman studies mug shots of wanted persons, straight from the dryer in the Manchester police photographic department during the Second World War. The arrival of thousands of American GIs during the war put extra strain on local police forces, which sometimes joined the MPs searching for troops wanted for theft or assault.

Left: A light-hearted moment in the dark days of the war. Two members of the police photographic department use the dark room for an impromptu serenade, complete with respirators.

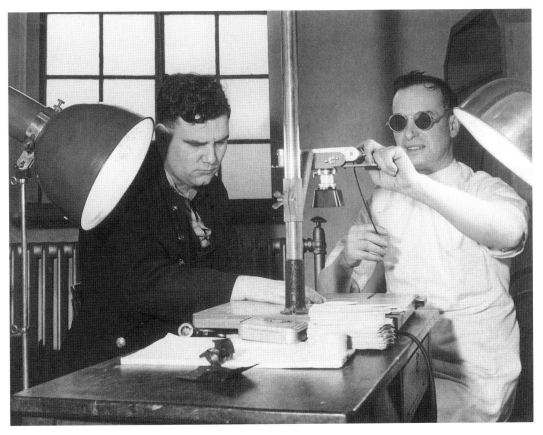

In a scene reminiscent of a 1950s science fiction film, a technician uses a photographic copying stand, assisted on the left by PC Harry Martin. Harry had worked as a laboratory assistant before the war and so was an ideal choice as one of the team of official wartime photographers. He went on to become head of the Manchester Police Photographic Department.

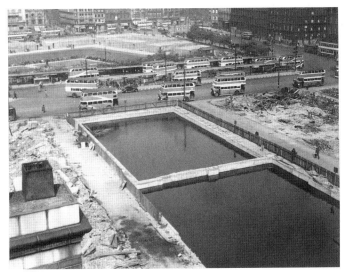

Static water tanks in Piccadilly, probably pictured in 1941. Uninterrupted water supply was a key requirement when fighting air-raid fires and in areas already flattened by bombing, cellars were made watertight and flooded to provide an emergency reserve. Notice also the reinforced brick and concrete surface shelters in Piccadilly Gardens itself, at the top of the photograph.

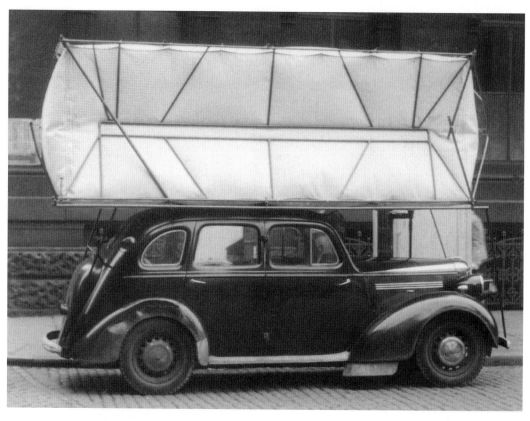

A wartime gas-powered car, possibly for police or official use. Although an ingenious way to avoid using precious petrol and diesel, the gas had to be carried in a cumbersome and vulnerable gasbag attached precariously to the roof.

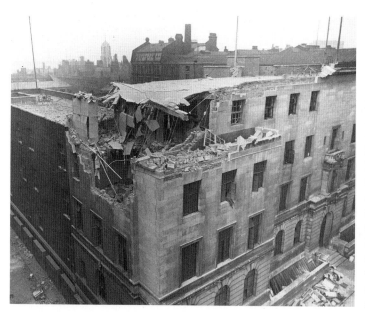

Bomb damage to Police Headquarters pictured on 5 June 1941. Two members of the Civil Defence Messenger Service were killed and others were injured, but staff in the control centre section of the building bravely continued to work during the raid, relaying vital information to the emergency and rescue services.

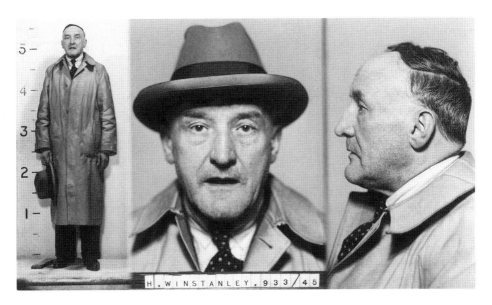

Herbert Winstanley, 'King of Forgers'. This modest-looking individual was one of the most skilled and prolific forgers ever seen in Great Britain. A reclusive single man, he rented two rooms in a terraced house in Lindum Street, Rusholme and between 1939 and 1945 he pursued his goal of producing the perfect forged banknote.

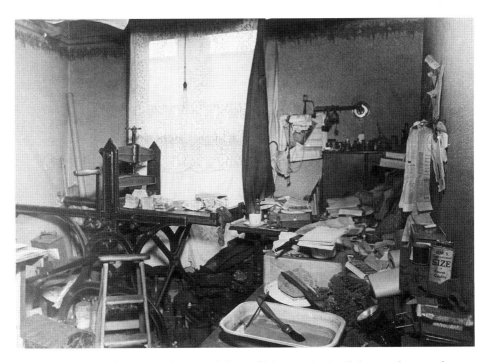

Winstanley converted one room into a workshop, which a trusting landlady agreed not to clean. A skilled engraver, it did not arouse suspicion when he stockpiled the tools of his trade in the workroom, which became his own private, if chaotic, kingdom. Months of patient work, engraving copper plates and etching blocks of lithographic stone, resulted in high-quality forged banknotes.

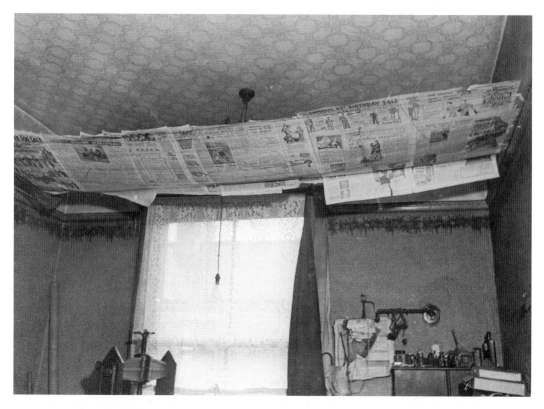

His notes were dried on a newspaper-covered clothes rack. Winstanley was then able to use his forgeries to place bets on greyhound races for the next six years without detection, until June 1945 when he placed a £4 bet on 'Bad Pace' at the Albion Stadium, Salford, comprising two real and two forged notes. Sadly for him, the two forged notes carried the same serial number and this was spotted. Detectives were summoned and Winstanley took them home to his workshop.

The astonished detectives found 8,730 forged one pound notes on the clothes rack and a further 2,498 forged £1, £5 and £10 notes hidden in boxes. Winstanley received a ten-year prison sentence, returning to Lindum Street on his release. But such was his reputation that the police continued to carry out discreet checks to ensure that the King of Forgers had put down his tools for good.

five

Post-War
Policing

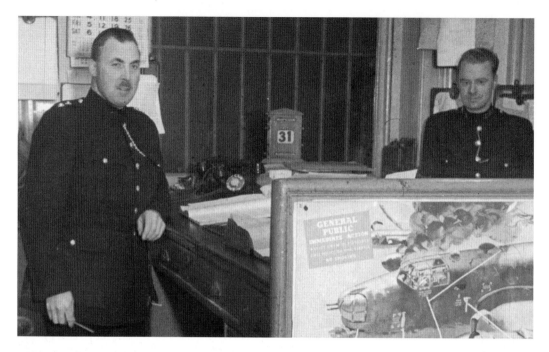

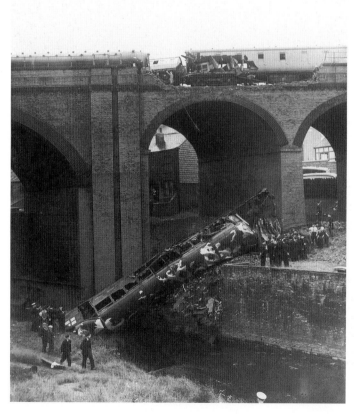

Above: PC Eric Auty (right) with an inspector in the enquiry office at Willert Street police station in the early 1950s. Worthy of note are the bars on the office window and the prominent poster, giving advice on how to rescue aircrew from a crashed plane – a hangover from wartime years when stricken aircraft might attempt crash landings on any convenient field or open space.

Left: Irk Valley Rail Disaster. On 15 August 1953, two trains collided on the Irk Valley railway viaduct. One coach plunged 90ft into the river and ten people were killed and seventy injured.

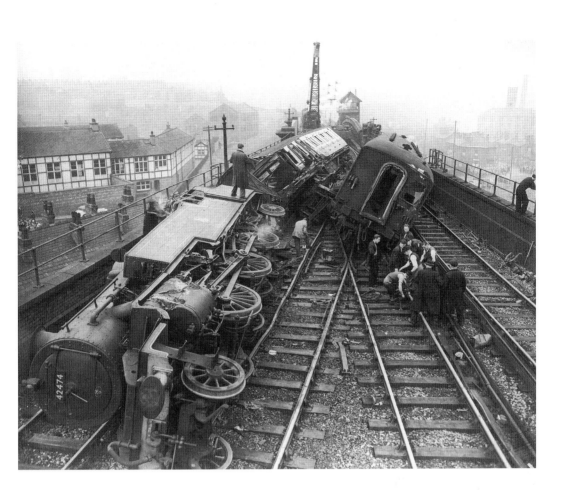

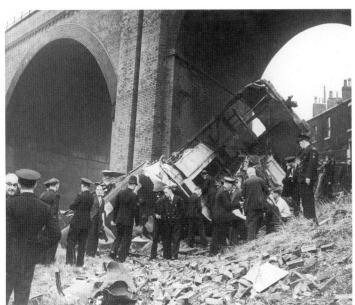

Above: The accident happened when a steam train – travelling from Manchester Victoria station to Bacup – crossed the path of an electric train travelling from Bury. The electric train veered off the tracks and the first coach containing fifty people broke from its coupling and smashed through the walls of the viaduct.

Left: During the inquest that followed the accident, many errors of the railway staff were unearthed. Two signalmen had failed to give a 'train approaching' signal and the driver of the electric train had not slowed down near the junction as protocol dictated. (By permission of the *Manchester Evening News*)

Above: New recruits photographed at the Regional Training College at Bruche near Warrington in 1953. No doubt these recruits were told that they had the potential of rising to the highest ranks – a potential realised in the case of PC Cyril James Anderton, pictured in the middle row third from the left, who later became Sir James Anderton and Chief Constable of Greater Manchester Police in 1976.

Left: A police constable from Mill Street station returns an escaped sheep to an abattoir in the 1950s.

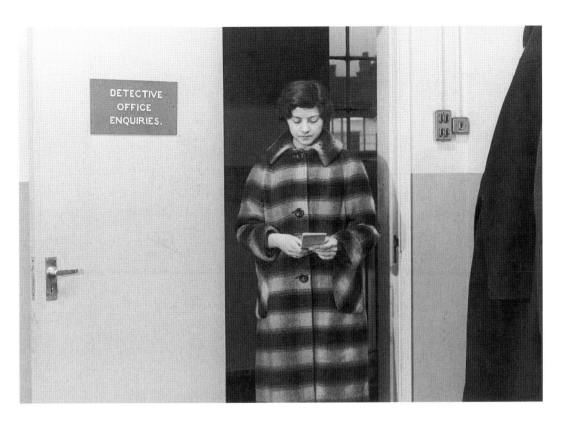

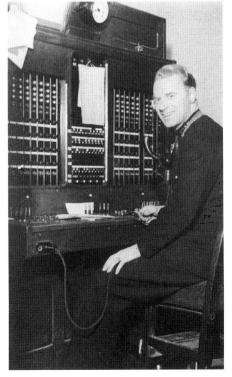

Above: A female detective enters the 'D.O.' Enquiries in plain clothes had been a feature of policewomen's work since the 1930s.

Left: Constable Eric Auty at the switchboard of Willert Street police station, in Collyhurst on the B Division, in the 1950s. This switchboard handled emergency calls from the telephone pillars located on the streets of the division as well as calls from private or business telephones.

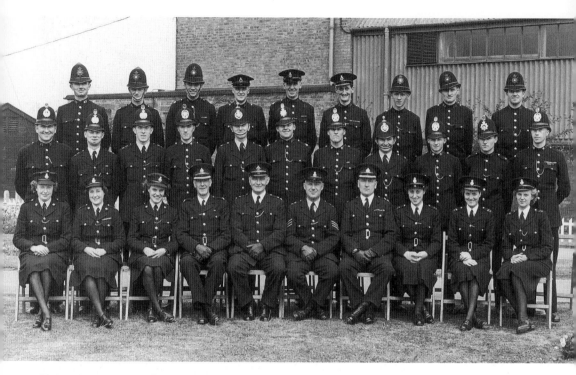

Trainer Sergeant Bert Ellison sits proudly with college staff at the centre of this group of probationary police officers at the Regional Training College at Bruche, near Warrington, during the 1950s. At this time the North West of England was policed by a huge variety of Borough, City and County police forces, and this is reflected in the range of headgear and badges worn by officers in the photograph.

Opposite above: Manchester City Policewomen in a church parade march through Albert Square, October 1959.

Opposite below: Time to relax: policewomen enjoy a canteen break in Bootle Street, late 1950s.

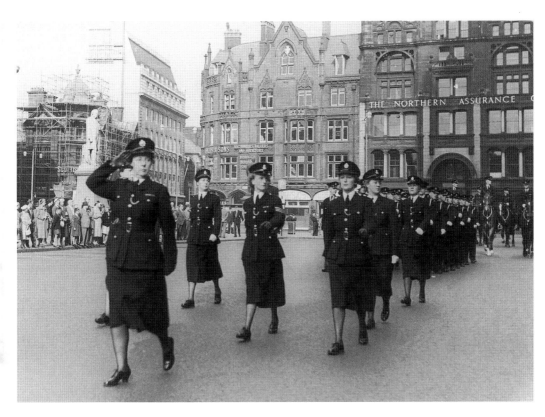

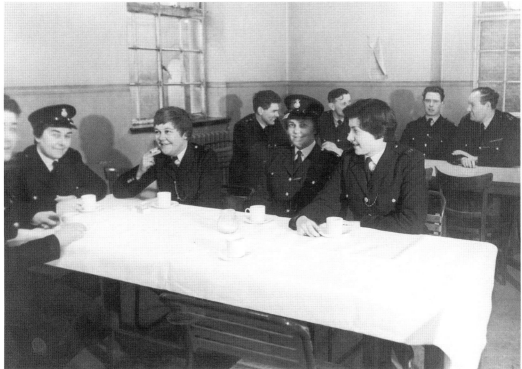

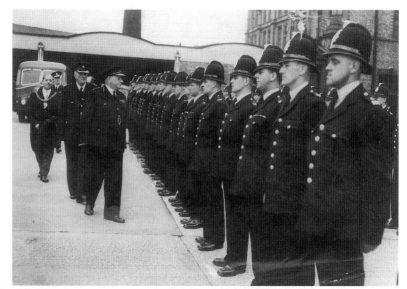

HMI (Her Majesty's Inspector of Constabulary) visit to Longsight police station, 1960s. The fifth officer from the right is PC Alan Warburton.

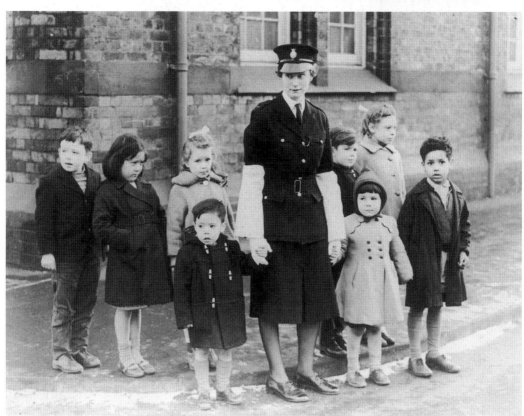

A policewoman on crossing duty in Manchester, 1963. In this year, supervision was provided at 220 places where children crossed busy roads on their way to and from school. This photograph marks the beginning of the end of police involvement in school crossing patrols, as members of the public were being encouraged to join the new School Crossing Patrol Service to reduce the burden on the police.

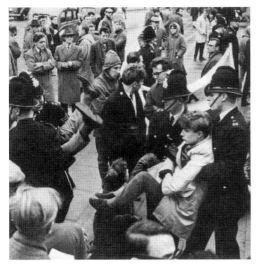

Left: The 1960s saw massive demonstrations across Britain by the CND (Campaign for Nuclear Disarmament). This photograph shows arrests being made in Albert Square in 1962. These marches – aimed at drawing attention to the threat of nuclear weapons – sometimes resulted in struggles with the police. Fifteen demonstrations took place in Manchester in 1962. On one occasion, there were thirty-seven arrests but in most cases the events were orderly and peaceful.

Below: A demonstrator is arrested and carried away by police, Albert Square, Manchester, 1962.

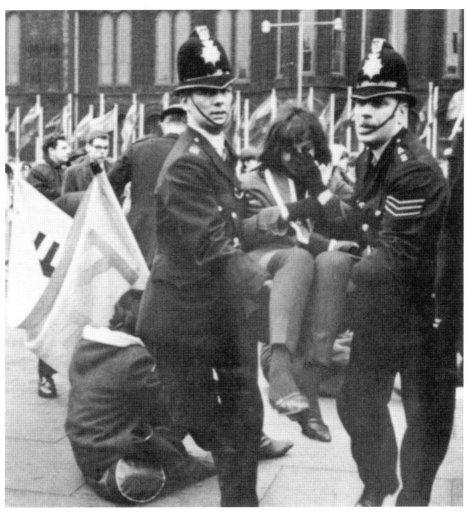

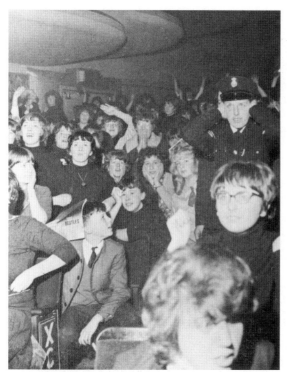

Left: Enter the Beatles: a Manchester audience's reaction to the band walking on stage in 1963. The Beatles played five venues in the city that year, the Three Coins Club, the Oasis Club, the Southern Sporting Club, and the ABC and the Odeon theatres. At this time 'Coffee Beat' clubs were becoming extremely popular in the city. No music or refreshment licenses were required and they were not open to police supervision. Music groups were engaged to play and the venues met with considerable success. By 1963, the first 'all night' session was held and the modern nightclub was born.

Below: Constable J. Oliver was commended by the Watch Committee for his courage when he brought under control a cow that ran amok in the streets in the vicinity of the abattoirs, 1963.

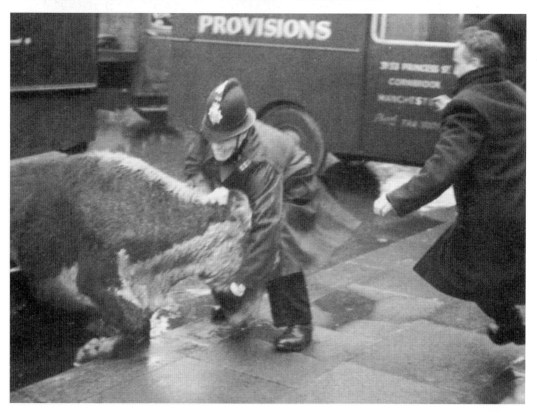

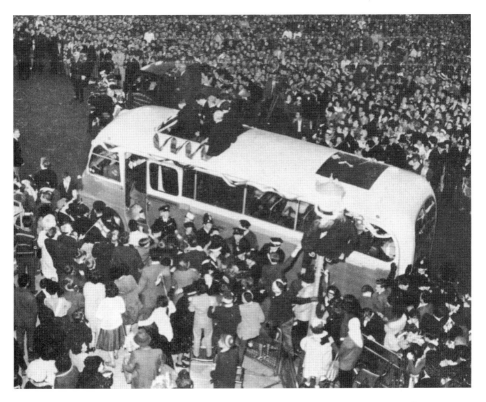

Manchester United cup winners' return to Manchester, 1963. The welcome given to the team on their return from Wembley after winning the FA Cup seemed even greater than in previous years. The crowds were denser than ever due to the fact that the team arrived at Central Railway Station (now the G-Mex Centre) and only had to travel a short distance to the Town Hall. The crowds had fewer streets to line!

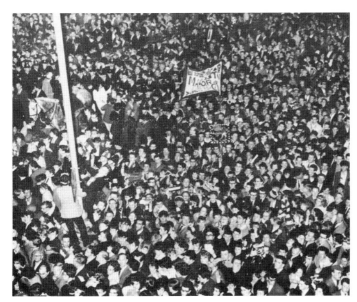

The large crowds greeting the team, 1963. Police described the fans as 'being good humoured, perhaps boisterous here and there'.

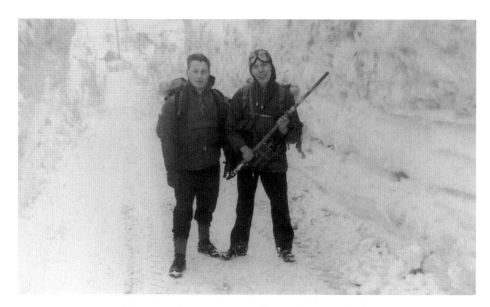

Police Cadets Pollitt and Quelch in a country lane near Jenkin Chapel, Rainow, Macclesfield, in January 1963. In those days it was normal practice for cadets to undertake an expedition across country, to promote leadership and self reliance, but even they must have been surprised at 8ft (2.4m) high snow drifts on either side of the lane.

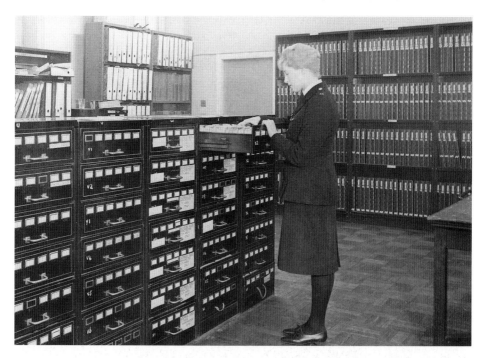

A policewoman searches for an address in one of the extensive card indices at headquarters in Bootle Street. Forces relied on the maintenance of such huge quantities of paper records in the days before computerisation of data, a process that did not begin properly in the Manchester force until the 1970s.

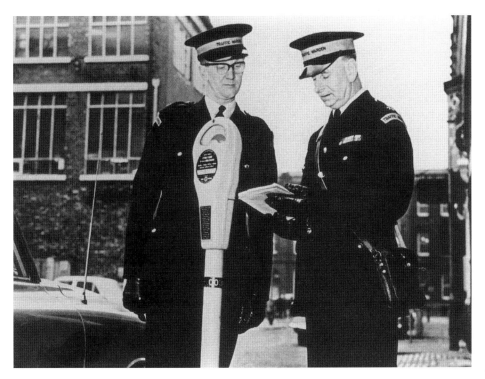

Two of the first members of Manchester's traffic warden service at work in the city. They began work in October 1965, and in their first year of operation the sixty wardens and seven senior wardens issued a total of 11,353 fixed penalty tickets.

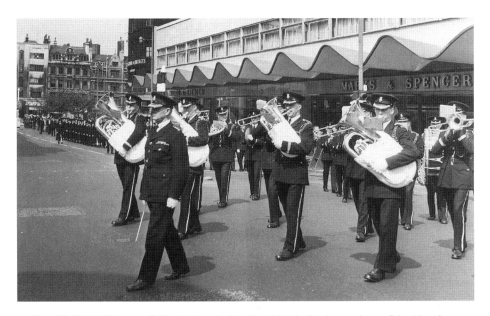

In the mid-1960s Director of Music Captain Geoffrey Hensby leads members of the Manchester City Police Band past the distinctive frontage of Marks & Spencer that was destroyed in the massive terrorist bomb explosion of 1996.

Right: Constable Ken Irvine, who in 1965 was awarded the George Medal for conspicuous gallantry. PC Irvine was on duty with another officer when they spotted a man placing a large object in the back of a car. The officers suspected that it might be stolen property and drove their police van towards the parked vehicle. Suddenly, the man got into the car and drove away at high speed. The two officers managed to get their van in front of the car. The man got out and ran off down a nearby entry closely followed by PC Irvine. Irvine felt a blow to his chest as he grabbed hold of the man. He fell to his knees but managed to retain his grip. Only then did he realise that he had been stabbed in the chest and the knife was still embedded. Quickly he removed the knife and held the man until the other officer could arrest him.

Below: A parade of Manchester City Police officers approaching the Town Hall, Albert Square, in the 1960s. The seventh from the right is Sergeant Albert Leach who eventually reached the rank of chief superintendent.

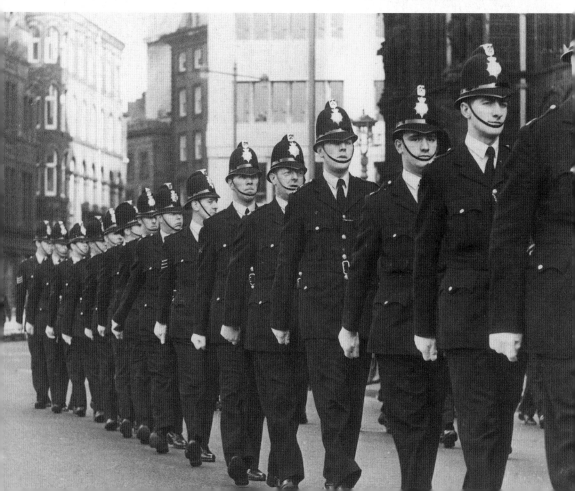

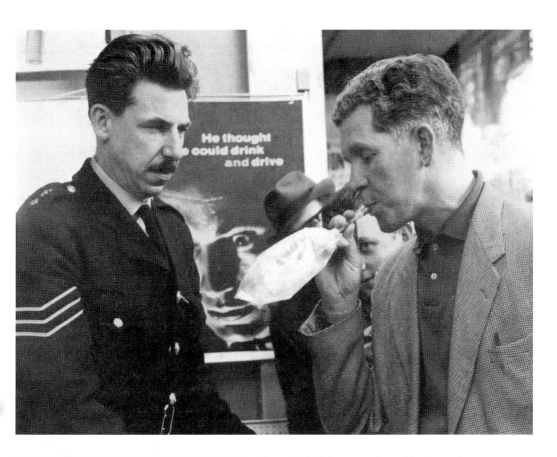

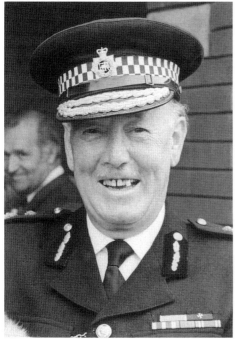

Above: A 1967 demonstration of the innovative 'breathalyser', which detected the presence of alcohol in the breath.

Left: Chief Constable William James Richards, who started his career on the beat in Birmingham in 1934. He became the last Chief Constable of the Manchester City Police in 1966. He was then the only chief constable of the short-lived joint Manchester and Salford Police force between 1968 and 1974. He became the first Chief Constable of Greater Manchester Police in 1974 and retired in 1976.

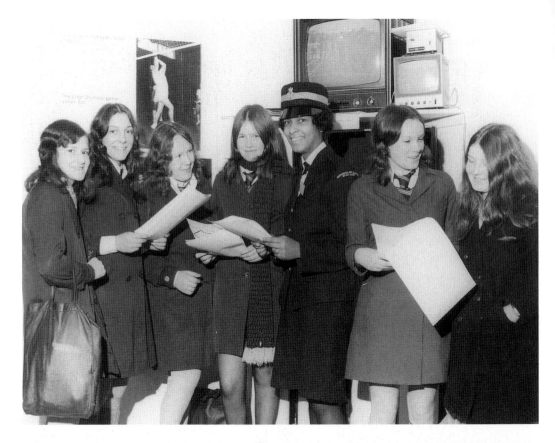

Above: Students from Longsight School talk to a cadet on the Manchester and Salford Police recruitment stand in 1972.

Right and opposite: '70s pioneers. In 1974 women officers could only carry out a restricted range of duties and did not receive equal pay. As soon as the Equal Opportunities Act was passed in 1975, women were able to get the same pay and to take up specialist roles in the police for the first time. Here are some of the pioneers – Karen Corcoran (Mounted Section), Janice Rudkin (Dog Section), Edwina Sykes (Motorcycle Wing) and Sandy McGurk (first to obtain HGV Class One Licence).

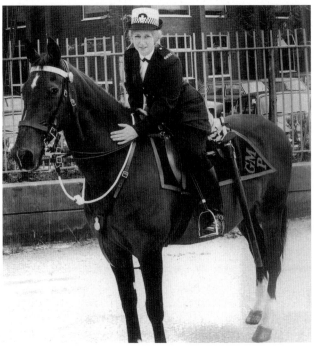

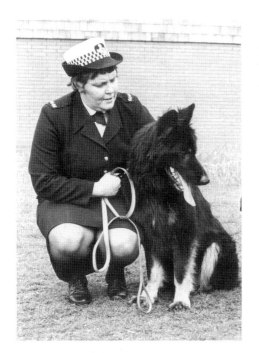

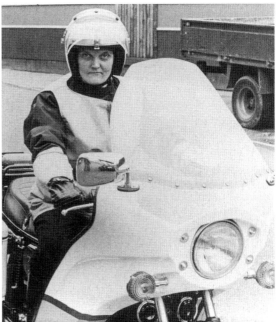

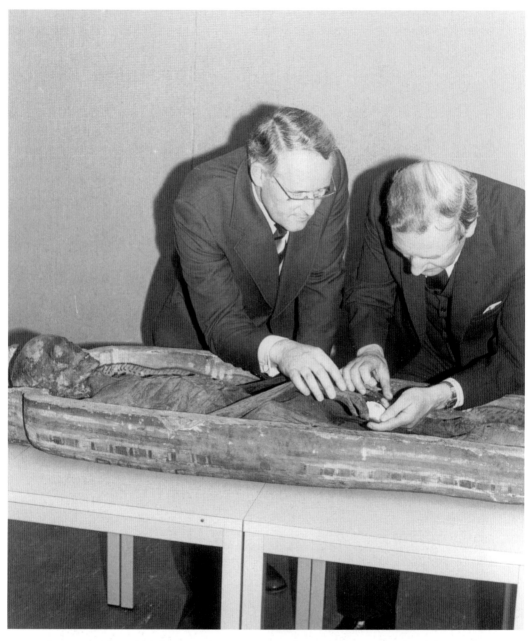

Detective Chief Inspector Tony Fletcher (left) fingerprints Asru, an ancient Egyptian mummy, as part of a joint project with Manchester Museum in 1976. The special techniques developed for taking prints from the 3,000-year-old temple singer were used only a year later to identify a more recently mummified body that had turned up in a shopping trolley in Rochdale.

Opposite, below: Moving day. Members of the personnel department prepare for the wholesale transfer of Greater Manchester Police Headquarters from Southmill Street to Chester House, a new office block at Old Trafford, in January 1979.

The opening of Grey Mare Lane police station on 21 December 1978 by guest of honour Sir Robert Mark. Grey Mare Lane replaced the old Mill Street police station, where the young PC Robert Mark, number C202, began a career that would take him to Leicester as chief constable and finally culminate with his appointment as Commissioner of the Metropolitan Police in 1972.

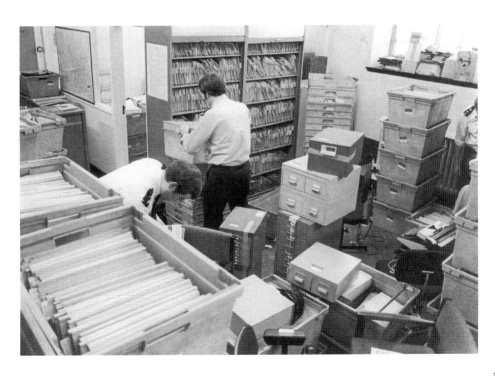

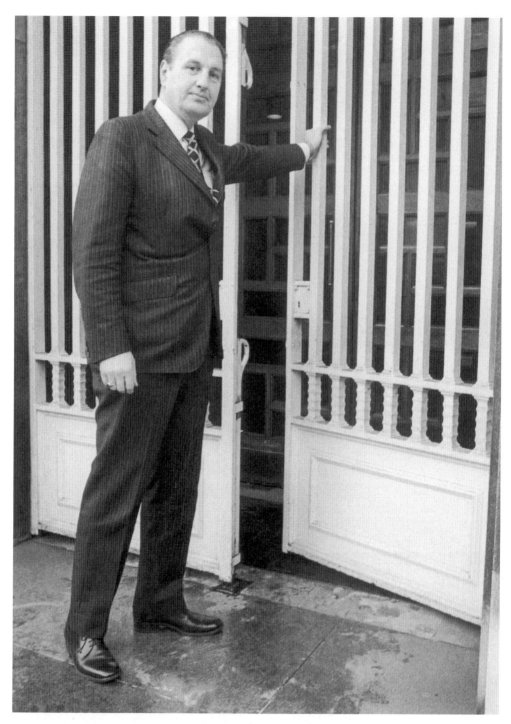

Chief Constable James Anderton closes the door to Southmill Street and with it a chapter in history. The departure from the old Manchester City Police Headquarters in 1979 meant that for the first time since the force was founded 140 years before, policing in Manchester would be run from outside the city boundary.

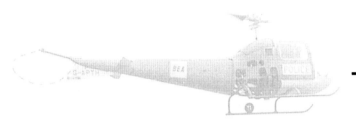

Police
Transport

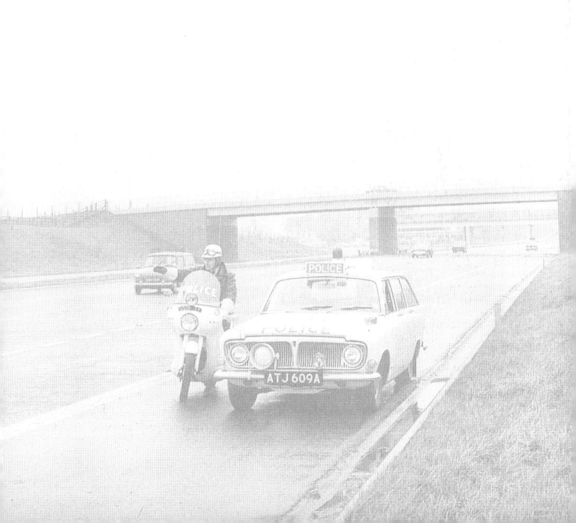

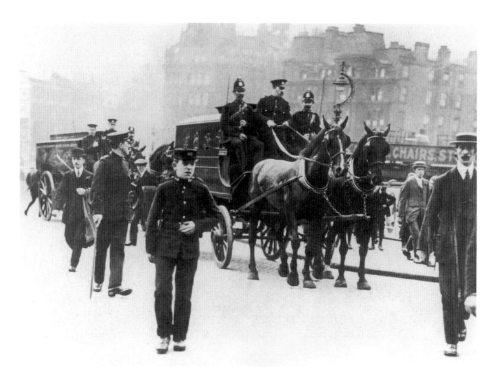

Two police 'Black Marias' make their way to Victoria Station in August 1914. Inside is not the usual collection of prisoners bound for court, but German nationals who have been rounded up following the declaration of war.

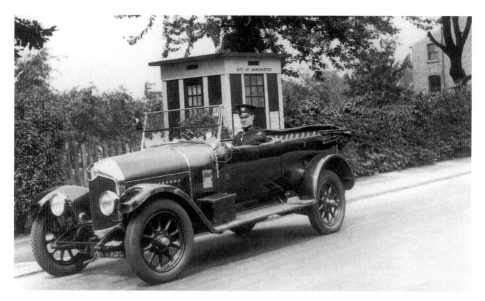

The telephone box and fast car were seen as the two essential elements of a new type of policing introduced in the late 1920s. The public could use the boxes to telephone for help and the police responded in cars and vans. It was envisaged that even the switchboard operators would be trained motorcyclists, so they themselves could respond in an emergency.

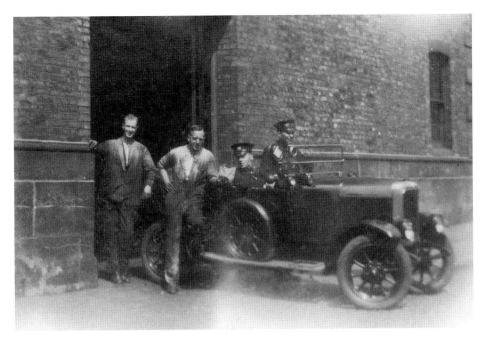

A rare view of two of the mechanics who kept the small fleet of police motor vehicles on the road in the 1930s. The increasing use of technology by the police in the period before and after the war led to the employment of more specialist civilians, later termed support staff. In the early days, however, police officers could be found carrying out all manner of tasks, from cleaning cells to answering the telephone switchboard.

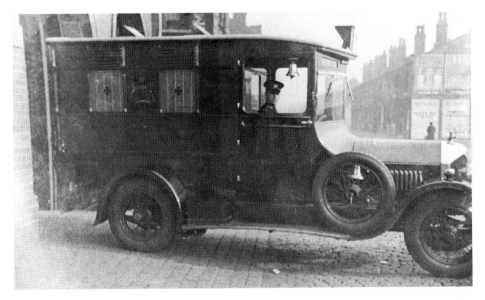

A Crossley Airbed Police Ambulance, seen outside Mill Street police station in the 1920s. The police continued to provide an ambulance service for Manchester until 1948, and they also had their own surgeons who would examine both victims of crime and drivers arrested on suspicion of drinking and driving. In 1927 Manchester Police appointed their first female police surgeon, Dr Nesta Wells.

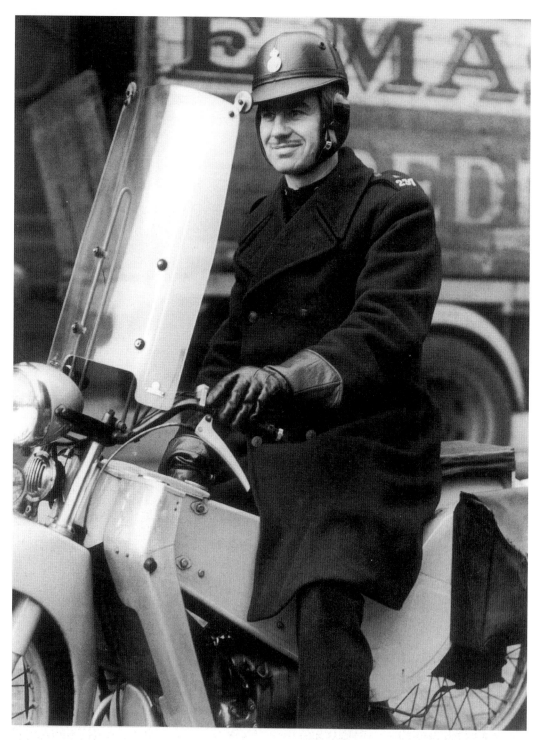

PC Tom Gothorp on a Velocette 'Noddy' bike, early 1960s. There are two explanations for this nickname. Firstly, that officers resembled the children's 'Noddy' character or more likely that officers had to repeatedly nod their heads towards sergeants and inspectors as they rode around their beat.

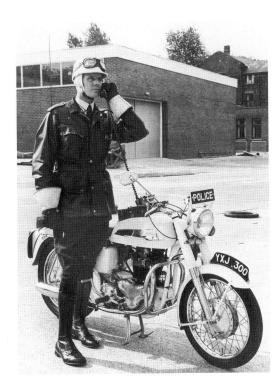

Left: A motorcyclist with his new Norton motorcycle, answering his radio telephone at Longsight police station. His specialist uniform includes a 'Corker' crash helmet and goggles, jodhpurs, gauntlets, leather leggings and stout boots.

Below: Inspector, later Chief Superintendent, Frank White, explains the workings of the motorcar to a group of keen officers at the Force Driving School, based at Longsight police station. The 'cut away' sports car was a popular teaching aid for many years.

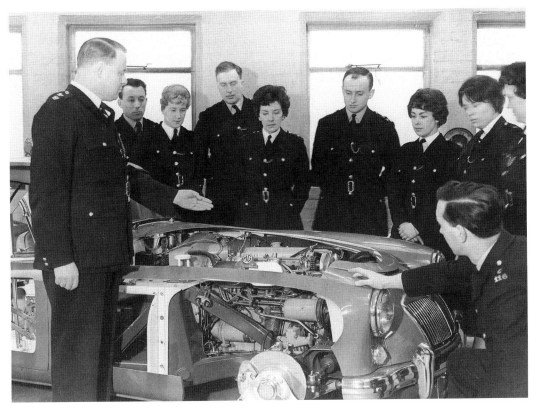

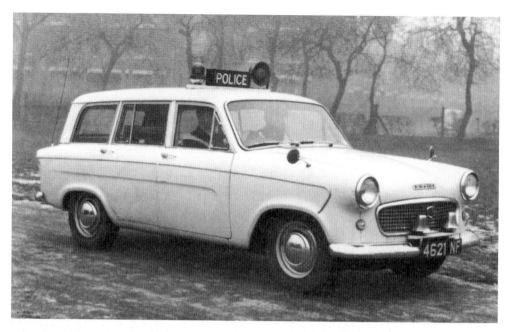

A Standard Ensign estate used as an emergency equipment area patrol car, Manchester, 1962. Note the twin bells. In Manchester, 4,622 people were either killed or injured in car accidents in that year. Nearly 25 per cent of these casualties occurred when pedestrians started to cross the road while masked from the oncoming traffic by stationary vehicles.

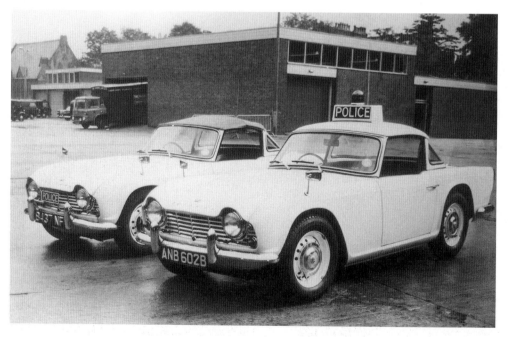

Hard top and soft top versions of the Triumph sports car at Longsight police station in the 1960s. At that time the Manchester City Police used 650cc motorcycles for the supervision of main road traffic, estate cars for dispatch to the scenes of accidents and white sports cars to intercept speeding motorists.

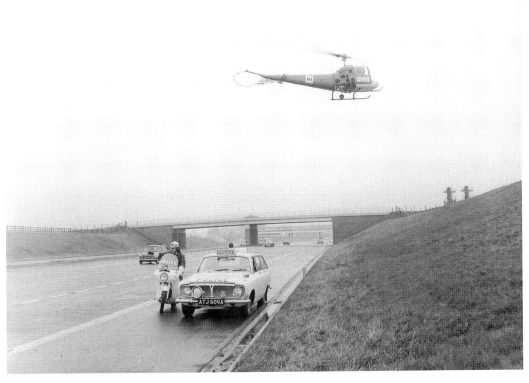

An experimental motorway patrol involving forces from the Manchester area in 1964. Note the early use of a helicopter, on loan from British European Airways, for monitoring traffic flow.

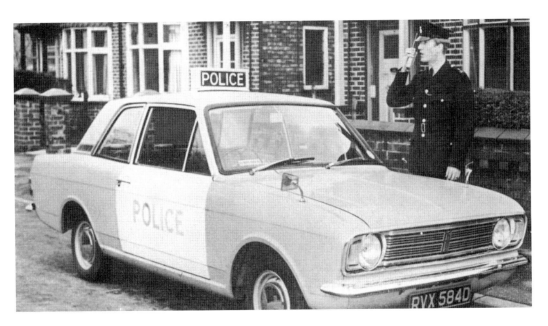

A constable using his personal pocket radio to contact his divisional station in 1966, as part of the Unit Beat scheme, also known as the Panda Car scheme.

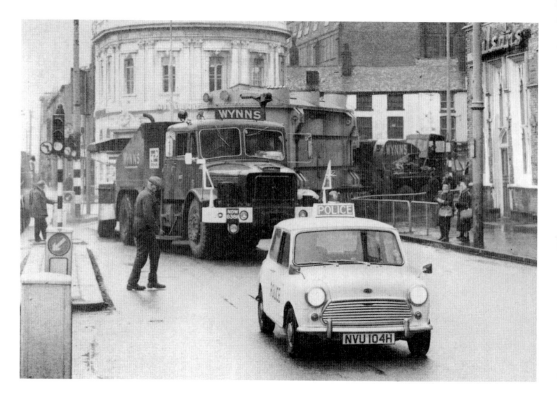

Above: A wide load is escorted onto Great Ancoats Street in 1969.

Left: The Major Incident HQ and Communications vehicle with radio aerials and beacon floodlighting unit extended, 1972.

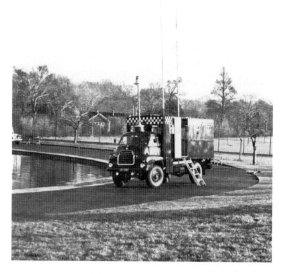

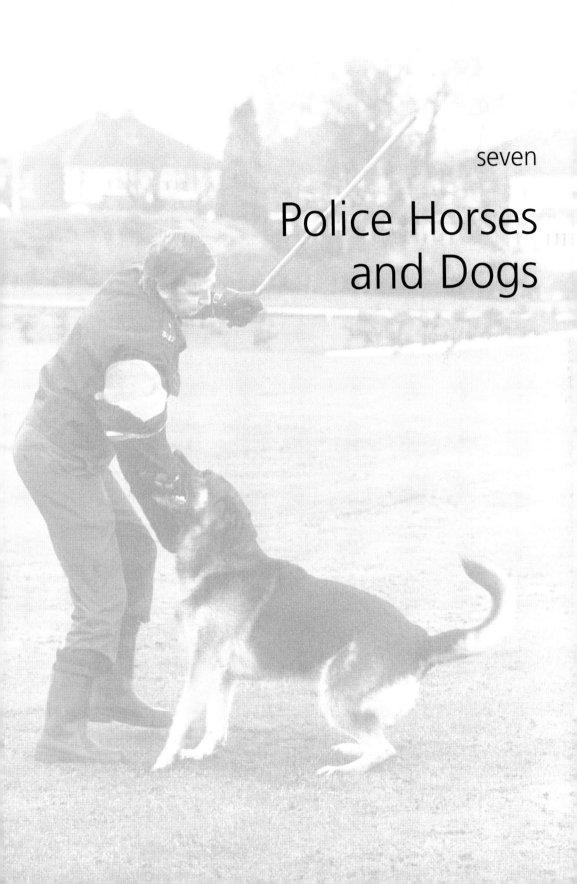

Police Horses
and Dogs

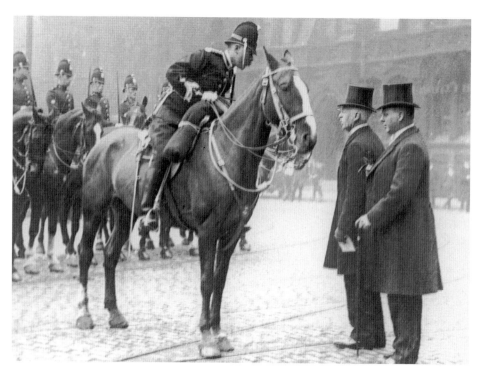

Manchester City Police Mounted Section inspection, Albert Square, *c.* 1900. By 1915, mounted patrols by special constables were introduced to make up for the deficiency in numbers, as many regular officers had joined the Military Police for war duties.

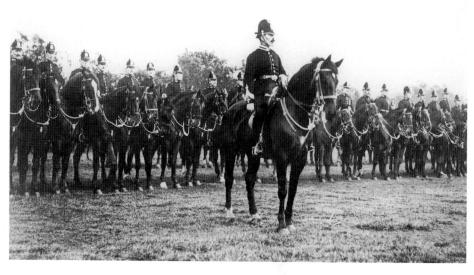

On Parade – the annual inspection of the branch at either Platt Fields or Birchfields Park, *c.* 1904. The senior Mounted Section officer (an inspector) is at the head.

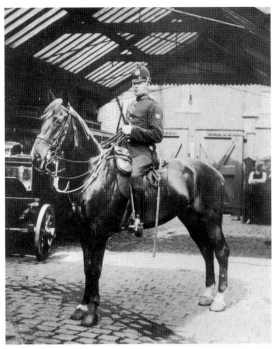

Left: PC 100 of the D Division, *c.* 1910. Notice behind the officer the 'Black Maria', the large horse-drawn vehicle used for conveying prisoners from police stations to the courts.

Below: A Manchester City Police Mounted Officer, *c.* 1911. One of the main duties of the section during this period was the supervision of traffic. The Manchester Police Mounted Section was originally supervised by the Inspector of the Ambulance Department but, due to his increasing workload, the Mounted Section received its own inspector in May 1921.

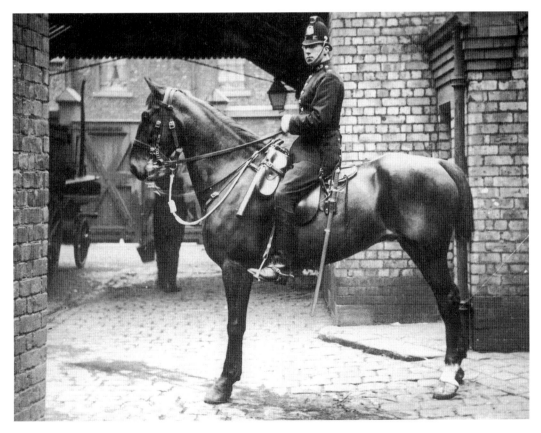

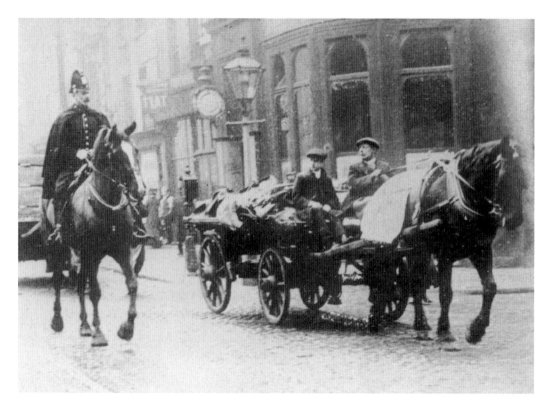

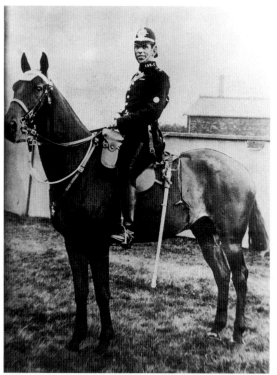

Above: Taken in 1913, a driver of a 'lurry' on Oldham Road is being cautioned by a mounted officer in his role as traffic policeman. Note the spelling of 'lurry', which at this time was used to denote a horse-drawn vehicle, as opposed to the term 'lorry' which was used for motorised vehicles.

Left: PC 156 of the C Division, *c.* 1920. He is wearing a ceremonial uniform, complete with spiked helmet and leather cross belt.

Opposite below: Manchester City Mounted Section 'parade order', *c.* 1926. Far right, leading off is Chief Constable Robert Peacock. Notice the officers' capes across the front of their saddles.

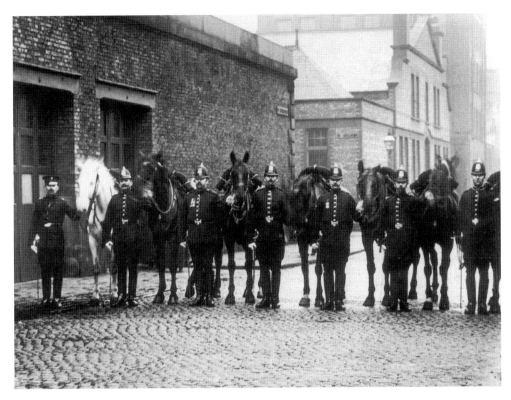

Above: Mounted officers outside Goulden Street police station, early 1920s. At this time the cost of a single horse was £75. This was a considerable amount of money for the period and as such it was a condition of sale that the horses had a trial period of six months in which they could be replaced if found to be nervous or physically unfit.

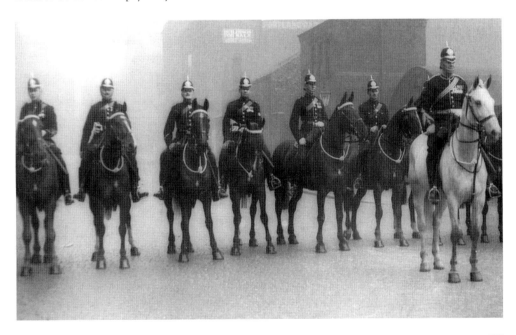

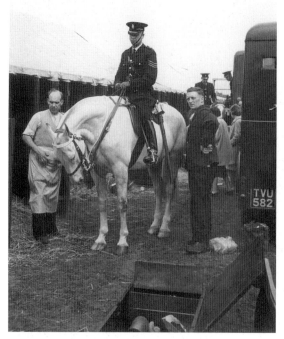

Backstage at the Newark Show, early 1950s.
As well as normal police duties and crowd
control, the Mounted Branch attended
events around the country, performing
dressage, musical rides and tent pegging.

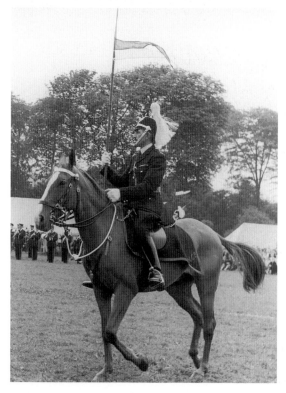

A Manchester mounted officer in full
ceremonial dress performs a 'musical ride',
c. 1960.

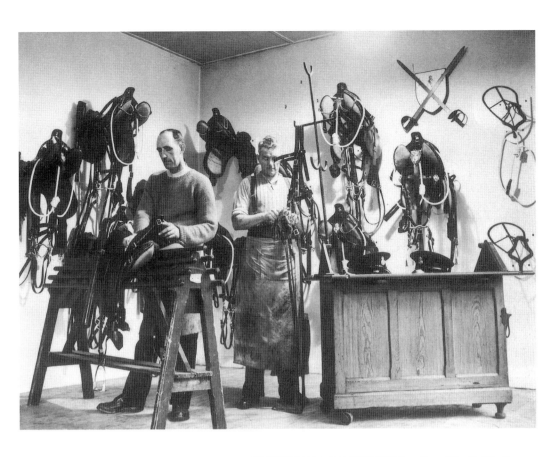

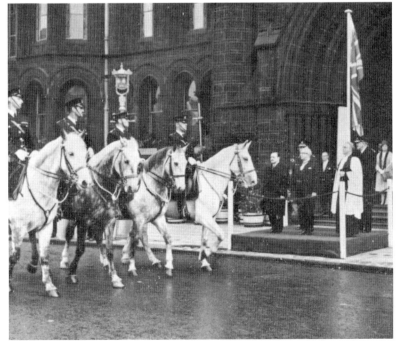

Above: The Saddle Room at Moss Lane East, Manchester, 1960s.

Left: Albert Square, 1964. Although used for crowd control duties, the Mounted Branch had regular daily patrols. In this year, the Branch 'laid informations' for 122 summonses, mainly for road traffic offences.

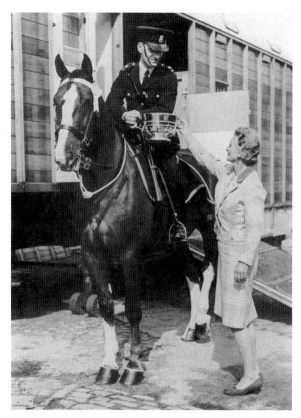

Left: Mrs M. Grant congratulates Constable R.H. Jackson after winning the Silver Rose Bowl in the Trained and Handy Horse Competition, 1965.

Below: Members of the Mounted Section taking part in a search for a missing child, 1966. The Branch had one inspector, one sergeant, twenty constables, four stable hands and twenty horses by this year.

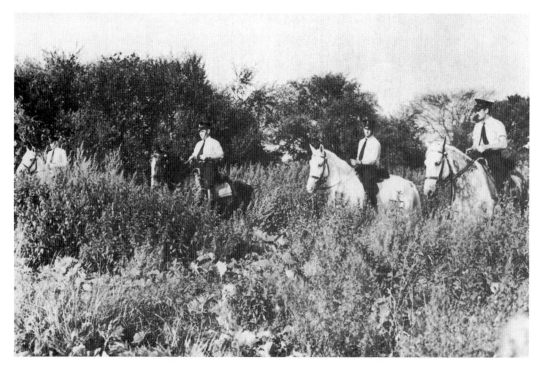

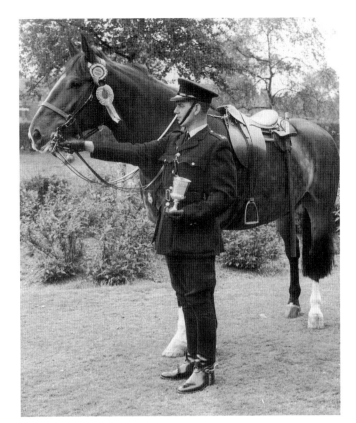

Right: Constable Ken Hurst and his prize-winning horse 'Copperfield' in 1967. It is still traditional for Greater Manchester Police horses to be named after characters from the novels of Charles Dickens.

Below: Mounted officers in ceremonial dress leading a procession on Cross Street in 1970.

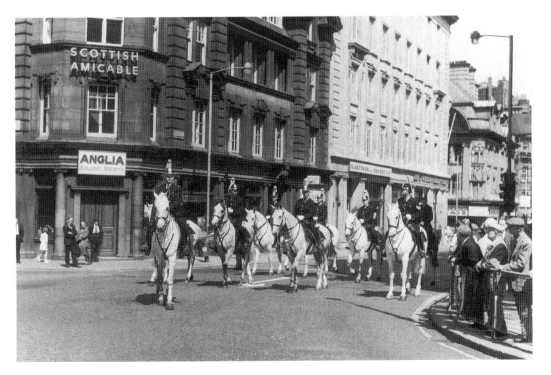

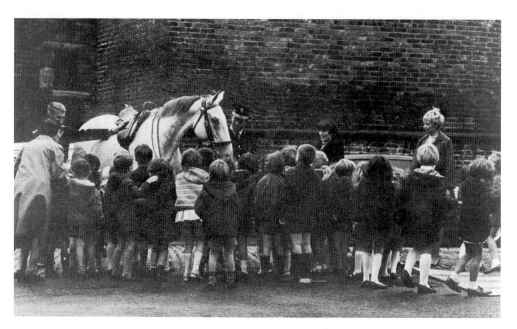

A party of children visiting the Mounted Department at Moss Lane East, 1971. By 1968, Manchester City Police had amalgamated with Salford. Numerous schoolchildren had visited the stables according to the 1971 Chief Constable's Annual Report and 'on all these occasions advantage was taken by the officers in furthering good police/public relations'.

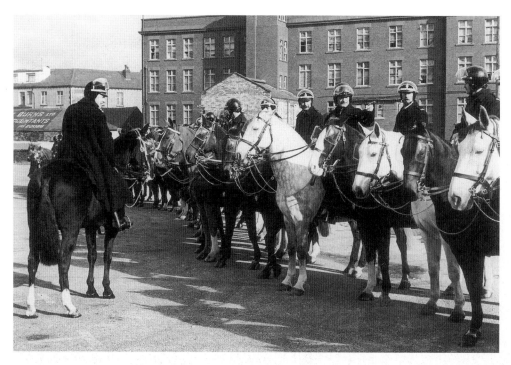

The Mounted Section, mid–1980s. Notice the protective eye shields attached to he horses' tack. The helmets worn by the officers were introduced in 1981 for public order duties.

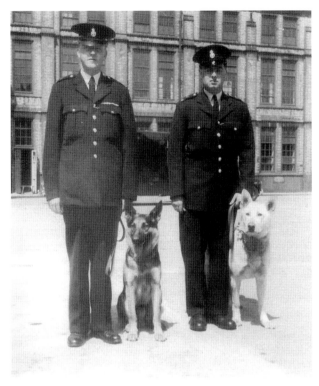

Left: William Hughes (left) and Gordon Stewart with their dogs Kim and Rinty, 1959, pictured outside Longsight police station. They were the first two dog handlers in Manchester City Police and were responsible for many arrests in connection with housebreaking, larceny, assault and disorderly behaviour.

Below: The Manchester City Police Dog Section, 1963. By this time the unit had increased from two dogs and handlers to four. From left to right: William Hughes, Bob Burton, Bill Butcher, Des McKenna.

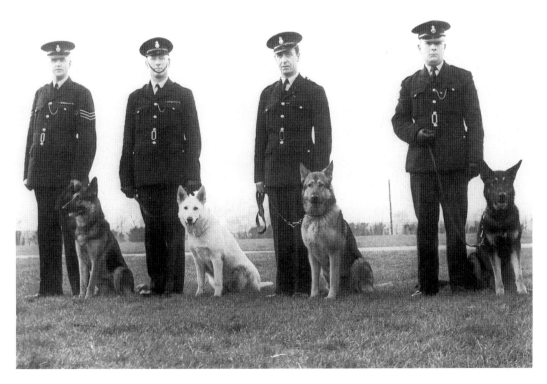

Above: Officers with a German Shepherd police dog, early 1960s. The Chief Constable's Report of 1959 stated that 'The effectiveness of the dog section is not solely reflected in positive results which are achieved, but also in the offences or aggravation of offences which are prevented'.

Left: Police dog 'Rex' and his handler Sergeant F. Leigh, winners of the British Alsatian Association Trials at Northampton, 1964.

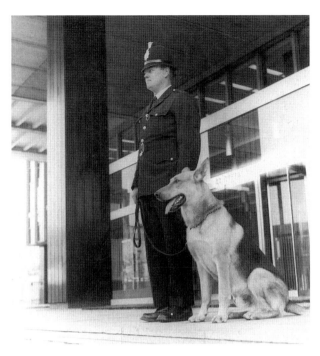

Left: PC Bob Harrop with 'Shep' outside the CIS building, Manchester, 1967.

Below: HMI Parry chats to a constable from the Dog Section during a force inspection in 1968.

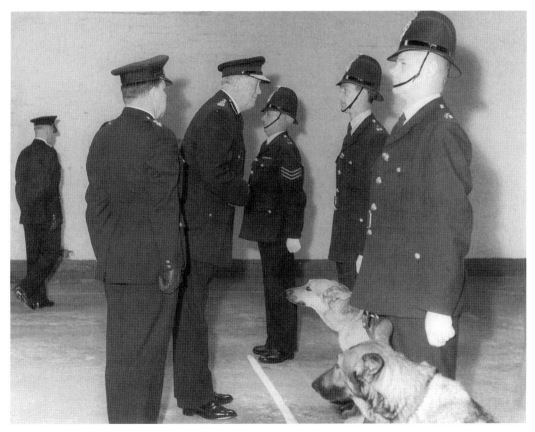

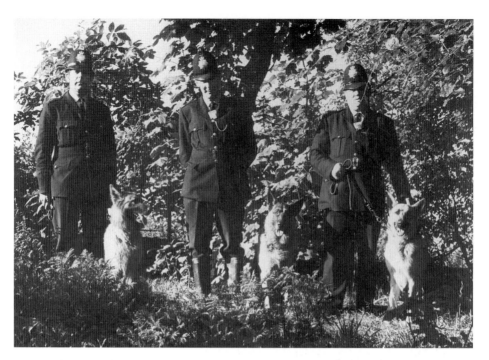

Dog handlers from Plant Hill police station, 1972. From left to right: Brian Davies, Jim Fallow, Danny Wallace.

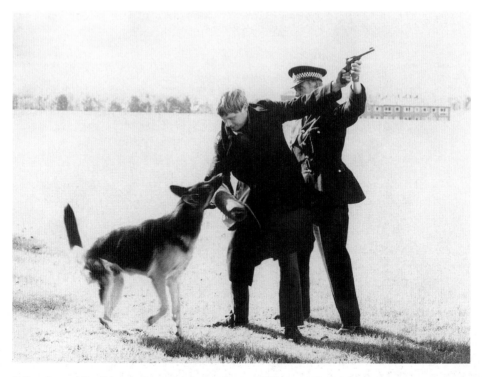

Police dogs with officers during a training session, *c.* 1970.

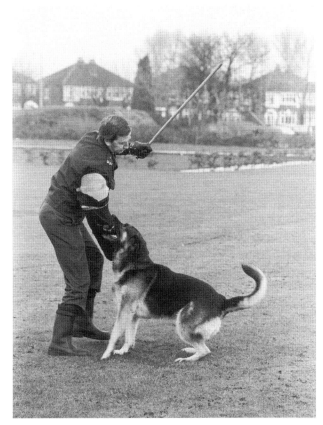

Left: Originally, police dogs fell into two categories: criminal tracking and executive. The criminal tracking dog was used to chase criminals by following a trail. The executive dog was used to chase and apprehend criminals, deter attacks on police officers and was also used at night when its superior senses helped the constable on the beat. Here trainer PC Kevin Mason demonstrates the fearless spirit of the police dog.

Below: Members of the Greater Manchester Police Dog Section make a security inspection of Heaton Park, prior to the visit of His Holiness Pope John Paul II in 1982.

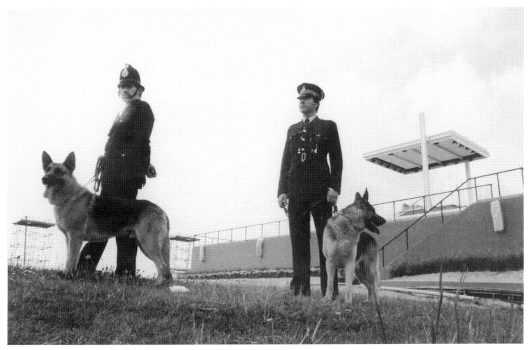

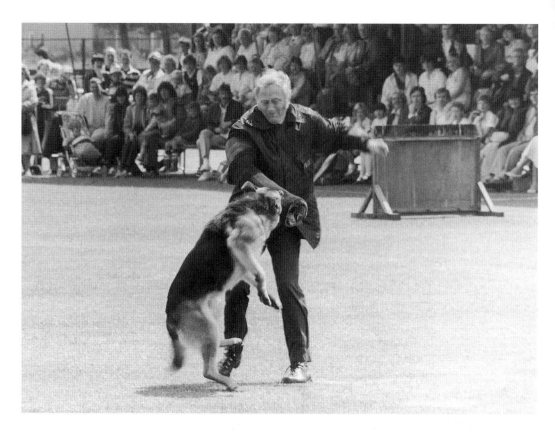

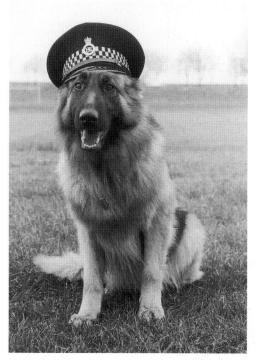

Above: A constable demonstrates the agility and expertise of the Dog Section to members of the public at a families open day, Hough End, 1986.

Left: Greater Manchester Police dog wearing official uniform! Early 1980s.

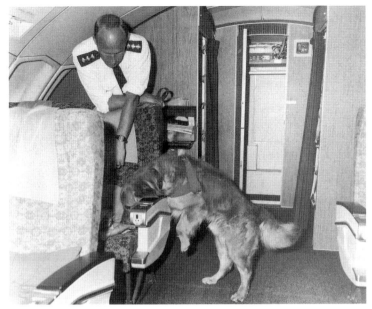

A Greater Manchester Police sniffer dog onboard an aircraft at Manchester Airport in 1985. By 1969, dogs were being purchased by the police for specialist training to detect drugs, explosives and human remains. Labradors, golden retrievers and spaniels are the preferred breeds.

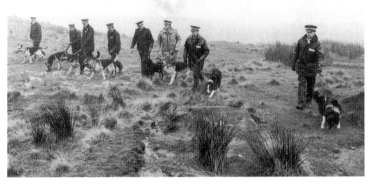

Greater Manchester Police Dog Section searching the open ground above Saddleworth during the Moors Murder enquiry, 1987. (By permission of the *Manchester Evening News*)

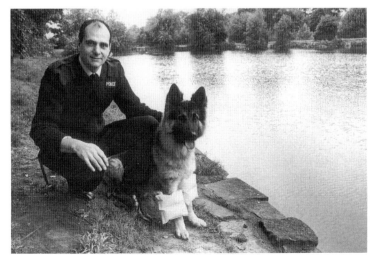

PC Phil Coghlan pictured with 'Raja', his German shepherd police dog in 1989 next to the reservoir at Debdale Park, Denton. Notice the armbands on the dog. Raja was swimming in the freezing water one cold day and got into difficulty about 50 yards out. She was battling to stay alive when Phil jumped in and had to rescue her. The dog soon recovered from her ordeal.

Other local titles published by Tempus

Clayton and Openshaw
JILL CRONIN

The East Manchester districts of Clayton and Openshaw have, over the last century and a half, experienced a sequence of industrial growth followed by recession, massive clearances and redevelopment. These fascinating old photographs show town and rural scenes, buildings, people at work and leisure and have been collected from a variety of local sources including the family albums of people who grew up there.

0 7524 3521 3

Champions – Manchester City 1967/68
PHIL GOLDSTONE & DAVID SAFFER

When Manchester City opened the 1967/68 campaign with a draw followed by two defeats, there was nothing to suggest a title challenge, but the Blues eventually saw off competition from Manchester United, Leeds and Liverpool to claim the First Division Championship. With match reports, illustrations and statistics, this book comprehensively recalls City's greatest ever League campaign when the Blues became kings of English football for the second time.

0 7524 3611 2

Voices of Dukinfield and Stalybridge
DEREK J. SOUTHALL

Oral history is unique in its facility to make the past accessible and to catch the flavour of a time and the lives of the people concerned. This book combines vivid memories with personal photographs of the interviewees, creating a valuable record of the first half of the twentieth century in and around Dukinfield and Stalybridge. The reminiscences range from childhood games to first-time jobs, memories of war and anecdotes of local characters, such as the man with two birthdays, and the last tripe dresser in Stalybridge.

0 7524 2679 6

Manchester's Ship Canal – The Big Ditch
CYRIL J. WOOD

The history of the MSC can be traced to the Stone Age. This book provides a history and guide to the Inland Waterways System around Manchester, chartering their development from ancient beginnings, to their importance in the Industrial Revolution, to current redevelopment projects. Cyril Wood is an established author, photographer and lecturer, who has had an active interest in canals and inland waterways since childhood, and writes with insight and enthusiasm.

0 7524 2811 X

If you are interested in purchasing other books published by Tempus, or in case you have difficulty finding any Tempus books in your local bookshop, you can also place orders directly through our website

www.tempus-publishing.com